IMAGES
of America

COVENTRY

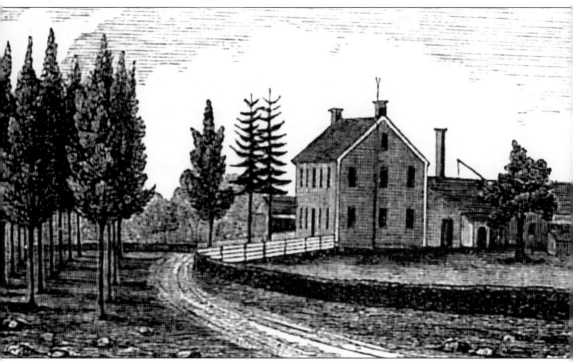

THE HALE HOUSE. This north view shows the Hale House, a John Warner Barber woodcut engraving from his book *Views of Connecticut Towns*, published in 1836. (Rose Fowler.)

IMAGES
of America

COVENTRY

Coventry Village Improvement Society

ARCADIA

Copyright © 2003 by Coventry Village Improvement Society.
ISBN 0-7385-1231-1

First printed in 2003.

Published by Arcadia Publishing,
an imprint of Tempus Publishing Inc.
2A Cumberland Street
Charleston, SC 29401

Printed in Great Britain.

Library of Congress Catalog Card Number: 2003105429

For all general information, contact Arcadia Publishing:
Telephone 843-853-2070
Fax 843-853-0044
E-mail sales@arcadiapublishing.com

For customer service and orders:
Toll-free 1-888-313-2665

Visit us on the Internet at www.arcadiapublishing.com.

On the cover: **THE 4H SEWING CLUB, C. 1940.** These young women include Phylis Gowdy, Janet Heckler, Mary Bowen, Betty Visny, Glenna Miller, Edna and Anna Giesecke, Josie Pesce, Justine Hoskie, and Amelia Kingsbury. (Robert Visny.)

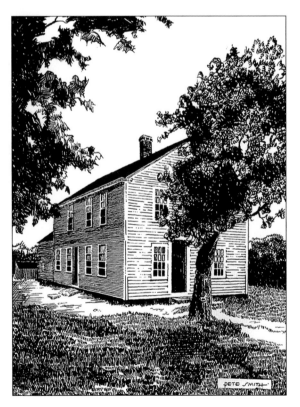

THE MARTIN BOX. This was the home of Orra Parker Phelps, who wrote *When I Was a Girl in the Martin Box*, a charming story of life in Coventry in the late 1800s. Published in 1949, it was written throughout her adult life and recounts her years in our small, rural town. (Rose Fowler.)

CONTENTS

ACKNOWLEDGMENTS

Our special thanks go to Arnold Carlson, former town historian, whose encouragement convinced us that this book should be published. He generously shared his large collection of photographs and postcards, and his extensive knowledge of Coventry history, particularly of the lake and mill industry. We are grateful to William Wajda, archivist and curator of the Coventry Historical Society, who gave many hours of his time, providing access to the archives and early Coventry photographs. The Connecticut Historical Society was also helpful in providing needed information. We acknowledge and thank the following people who met with committee members to share their photographs, postcards, and memories: Ethel Crickmore Harris, Walter Jacobson, Robert Visny, Fred White, Lois Frankland, Charles and Fran Funk, William Ayer, François J. Gamache, and Donald and JoAnn Aitken. Finally, we could not have completed this book without the assistance of the following community-spirited residents who have helped to weave together this rich tapestry of Coventry's past: Erica Sarnik, Jim Wicks, Chic Bearce, Jack Lacek, Chuck Blanchard, Walter Plowman, Joy Kelleher, David Mortlock, Shirley Wright Edmondson, Joseph Fowler, Frank Kristoff, Judy Hill, Judy Hynes, Sandy Sanborn, Erik and Alysia Williams, Karen and Herb Van Kruiningen, Tom Franz, Joan Lewis, Vincent and Carol Moriarty, Edward W. Cook, Coventry Grange, Booth and Dimock Library, Antiquarian and Landmark Society, and the town of Coventry.

—Authors and members of the Coventry Village Improvement Society
Gary Dilk, Rose Fowler, Patricia Pelkey, and Kara Polo

INTRODUCTION

Coventry was known to the Native Americans as Wamgumbaug, "crooked pond," from the curved shape of the large body of water within the present town limits. It was set off in 1706 to be divided by deed holders from the legatees of Joshua, third son of the Mohegan sachem Uncas. The original town layout is a town planning classic. The area was settled in 1709, named in 1711 for the city of Coventry, England, and incorporated in the following year.

Here is the birthplace of the martyred patriot Capt. Nathan Hale, whose immortal last words on the British gallows were, "I regret that I have but one life to lose for my country." Jeremiah Ripley, continental commissary, maintained a military provisioning depot at his homestead on Ripley Hill during the Revolutionary War. The town was an important stopover on the great Hartford–Boston Turnpike road (1798) and the starting point of the Windham Turnpike to Norwich (1820).

Here were the homes of Joseph Meacham, pastor; John Potwine, silversmith; Daniel Burnap, clockmaker; Joseph Badger, miniaturist-portraitist; Jesse Root, jurist; Lorenzo Dow, revivalist preacher; John Turner, glass merchant; Addison Kingsbury, paper-box manufacturer; and Henry Mason, cartridge maker. Coventry was noted for early manufacturers of paper, wool, silk, cotton, woven hats, commemorative glass flasks and inkwells, ammunitions, wagons, and cardboard boxes. From the time of the Civil War until the onset of the Great Depression in 1929, the mills of South Coventry prospered. So, too, did the North Parish family farms. The trolley line (1909), connecting at Willimantic to Norwich and beyond, was the excursionist's delight for over a decade before the automobile era.

Nationally known stars of vaudeville and early radio founded the Actor's Colony at Coventry Lake in the late 1920s, among them the Loesers, Fitzgeralds, Hinkles, MacLallans, Kamplains, and Keenes. (The information above is from the Coventry Plaque in front of Coventry Town Hall.)

The photographs in this book provide a glimpse of Coventry's history from the late 1800s through the early 1950s. They offer a view of the charming village and lake as they were in earlier times. They re-create the excitement of the arrival of the trolley and show the significance of the mill industry. They picture not only the very well-known individuals but also the farmers, shopkeepers, and everyday people who have lived, worked, played, and prospered in Coventry.

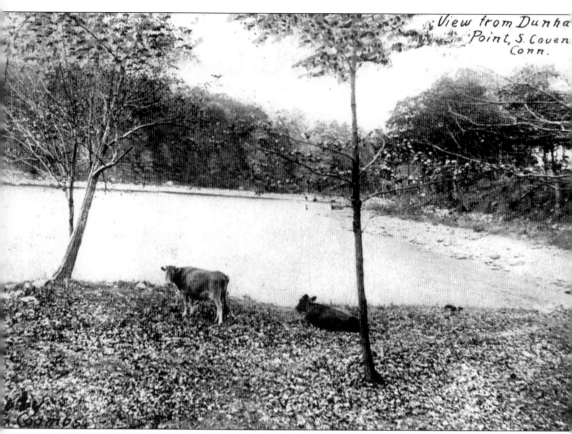

A VIEW FROM DUNHAMS POINT. This is the part of Sandy Shores where the land juts out to the right. When this area was a Salvation Army summer camp location, the name was changed to Bates Point to honor a captain in the Salvation Army. (Rose Fowler.)

One

PEOPLE REMEMBERED

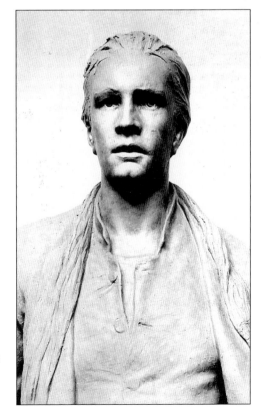

NATHAN HALE. Although 116 of Coventry's 2,056 residents served in the Revolutionary War, one man's exemplary effort stands apart from the rest. Nathan Hale, a Yale graduate and New London schoolmaster, volunteered in 1775, leaving his post for what he described as "an opportunity for more extended public service." Within a year he was promoted to captain. He soon answered an appeal for an officer to gather information on Howe's British troops on Long Island. He was captured and hanged as a spy the next day, September 22, 1776, at the age of 21. His last words, "I regret that I have but one life to lose for my country," reflect the depth of his patriotism and devotion to duty. This is a photograph of the Nathan Hale statue, by sculpture Bela L. Pratt, located on the Yale campus. (Patricia Pelkey.)

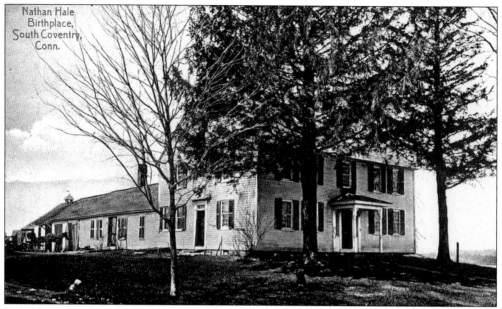

Nathan Hale Birthplace, South Coventry, Conn.

THE HALE MANSION, 1776. This *c.* 1909 view shows the Hale Mansion, now called the Hale Homestead, built in 1776 by Nathan Hale's father, Richard Hale, who was a deacon. Born in 1755 in an earlier home on this site, Nathan Hale never lived in the new house. (Rose Fowler.)

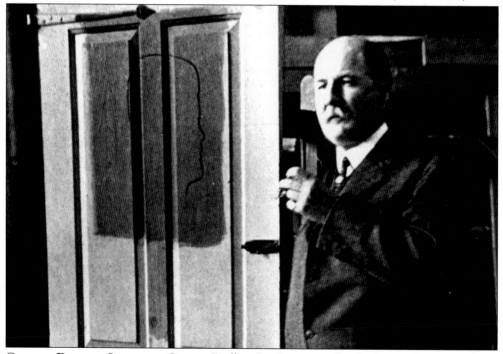

GEORGE DUDLEY SEYMOUR. George Dudley Seymour proudly displays a shadow portrait beneath the paint on a chamber door. In 1914, Seymour, a New Haven patent attorney and antiquarian, purchased the house and 65 acres for the sum of $5,000. Just prior to the purchase, he discovered the portrait, believed to be that of his boyhood hero, Nathan Hale. (Antiquarian and Landmarks Society.)

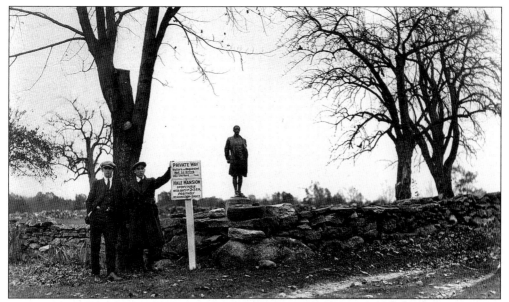

A STATUE OF NATHAN HALE. A miniature version of the Bela L. Pratt statue once stood at the birthplace of Nathan Hale, in Coventry. Upon his death in 1943, George Dudley Seymour left the home to the Antiquarian and Landmarks Society. The Hale Homestead, located on South Street, opened as a museum on June 6, 1948. (Rose Fowler.)

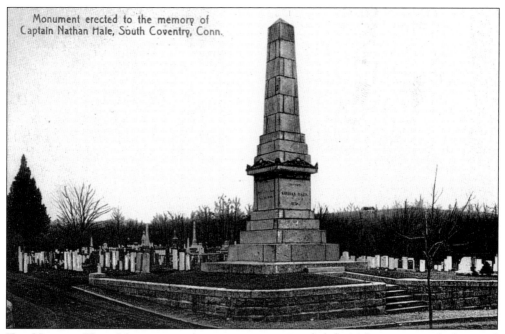

THE NATHAN HALE MONUMENT. An impressive granite obelisk, 14 feet square at the base and 45 feet high, was developed from the original design of renowned architect Henry Austin and competed by Solomon Willard, architect for the Bunker Hill Monument. It was dedicated on September 17, 1846, following a 10-year effort by the townspeople of Coventry. The monument is located at the entryway of the Nathan Hale Cemetery on Lake Street. (Patricia Pelkey.)

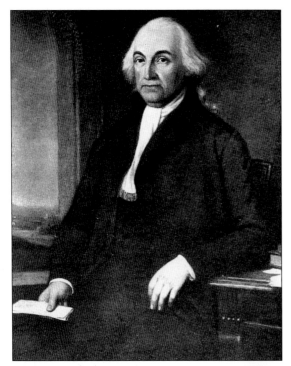

JESSE ROOT. Born in Coventry on December 28, 1736, Jesse Root graduated from Princeton in 1756. After three years as a minister, he studied law and was admitted to the Hartford County Bar in 1763. He served as a lieutenant colonel in the Revolution and was a delegate to the Continental Congress between 1778 and 1783. He was a judge of the state superior court and served as chief justice of Connecticut from 1796 to 1807. Four years before his death, he opened the Constitutional Convention in 1818, at the age of 82. (Photograph of a painting, from the *Official Program, 1912 Celebration.*)

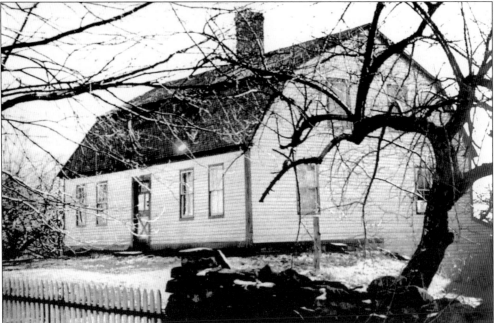

THE JESSE ROOT HOMESTEAD, 1732. Located on Route 31 near Ripley Hill Road, the Root Homestead is a gambrel-roofed, center-chimney cape with six fireplaces, paneling, dental molding, wainscoting, and original hardware. The house is reported to have been built by slave labor. The slaves' quarters are in the basement where there is a long kitchen room containing an immense fireplace and brick floor. According to folklore, one of the slaves is buried beneath the floor. (Connecticut Historical Society, 1935.)

THE GRANT CONNECTION. Jesse Root Grant, son of Noah Grant, was the father of Ulysses Simpson Grant, the 18th president of the United States. Noah Grant resided in Coventry *c.* 1750, and married Anna Buell Richardson in 1775. Anna died in 1789 and is buried in the Grant Hill Cemetery, on Grant Hill Road in Coventry. Noah moved to Pennsylvania and married Rachel Miller Kelly on March 4, 1792. Jesse Root Grant was born on January 23, 1794. He married Hannah Simpson, and their first son, Ulysses Simpson Grant (pictured) was born on April 27, 1823, in Mount Pleasant, Ohio. (Joseph Fowler.)

HARLAN PAGE. Born in Coventry in 1791, Harlan Page was "awakened" in 1814, whereupon he converted and joined the ministry. He served in Boston, Jewett City, and Coventry. He organized the first Sunday school in Coventry, traveled a great deal, and converted many of the faithless to the Baptist Church. A large Baptist revival was held in Coventry in 1822. Page died in 1834, in New York, where he was affiliated with the American Tract Society. He is buried in Coventry, and his home still stands on Route 31. (Rose Fowler.)

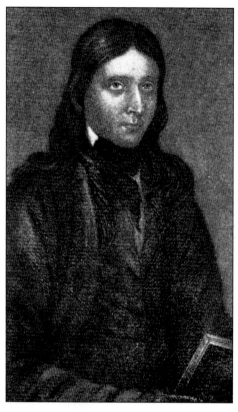

LORENZO DOW. Born in Coventry on October 5, 1777, Lorenzo Dow was an eccentric and independent itinerant Methodist minister whose zealous spirituality impelled him on a mission of conversion throughout the eastern United States, England, and Ireland. He frequently noted the value of his reputation as "Crazy Dow" in bringing congregations to his camp meetings. At his death on February 2, 1834, he was considered the most widely known and perhaps most traveled man in America. Portraits of him and his wife, Peggy Dow, permanently remain in the original Dow home by deeded covenant. (Herbert and Karen Van Kruiningen.)

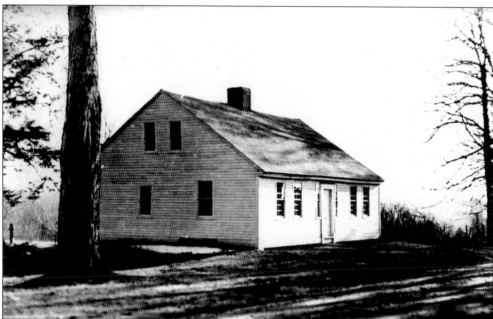

THE DOW HOUSE, C. THE 1770S. Located on Parker Bridge Road, this is the home in which Lorenzo Dow was born. His parents, Humphrey B. and Tabitha (Parker) Dow, were also natives of Coventry. (Connecticut Historical Society, 1935.)

ADDISON KINGSBURY. Born in Coventry on November 15, 1835, Addison Kingsbury died in 1914 and is buried in the Nathan Hale Cemetery. In an 1891 biographical sketch by J.A. Spaulding, Kingsbury is described as "one of the most noted and successful paper box manufacturers in New England." He started the Kingsbury Box and Printing Company in Coventry in 1868 and expanded to four other locations in Connecticut and Massachusetts. He also invented several machines that improved the production of paper boxes. (Charles and Fran Funk.)

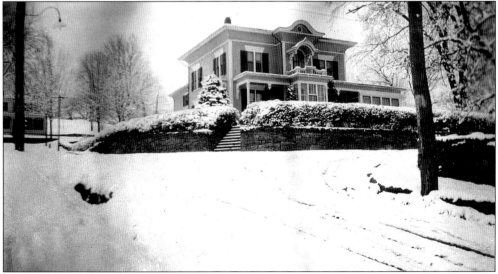

THE KINGSBURY HOUSE, C. 1860. This home is located on the corner of Wall and Mason Streets, overlooking the Kingsbury Box and Printing Company. It is described in the *1990 Historic Resources Inventory* as one of the finest Italianate-style houses in Coventry. (François J. Gamache.)

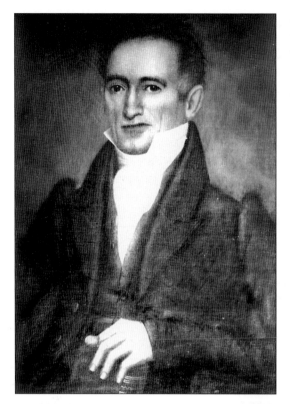

THE REVEREND CHAUNCY BOOTH.
Born in 1783, Chauncy Booth graduated
from Yale in 1810 and went directly to
the Anderson Theological Seminary.
He accepted a call to the ministry
from Coventry and was ordained on
September 20, 1815. Booth served as
pastor of the First Congregational
Church for more than 40 years. He
retired in 1844 and died in Coventry
in 1851. (Booth and Dimock
Memorial Library.)

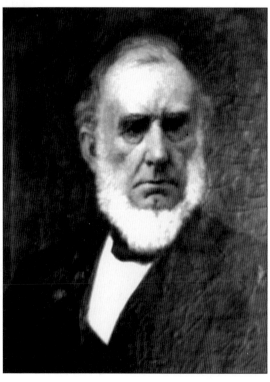

DR. TIMOTHY DIMOCK. Born in
Coventry on April 7, 1800, Timothy
Dimock graduated from Yale in 1823
and served as a physician for 45 years.
He was elected to the Connecticut
State House of Representatives in 1838
and to the Connecticut State Senate in
1846. (Photograph of a painting at the
Booth and Dimock Memorial Library.)

Henry Farnum Dimock, Esquire.
Born in South Coventry on March 28, 1842, Henry Farnum Dimock was a graduate of Yale and a lawyer, businessman, and philanthropist. Upon his death on April 10, 1911, he bequeathed $40,000 to the South Coventry Library Association for a library building, giving the following dedication: "In perpetuation of the memory of my grandfather, the Reverend Chauncy Booth, a long time pastor of the Congregational Church in South Coventry, and of my father, Dr. Timothy Dimock, who was born in South Coventry and practiced as a physician during his long and useful life." (Booth and Dimock Memorial Library.)

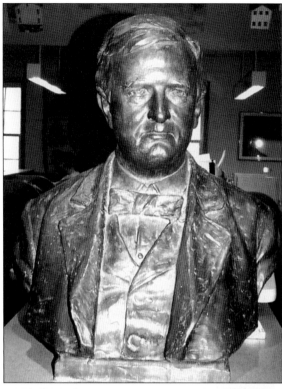

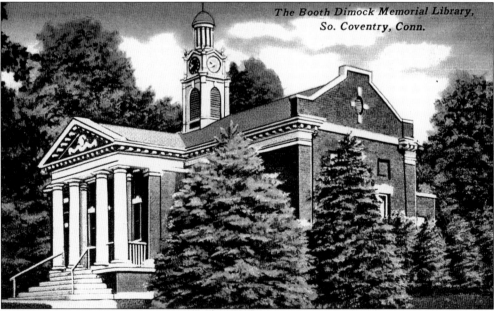

The Booth Dimock Memorial Library, So. Coventry, Conn.

The Booth and Dimock Memorial Library. The library was built in 1912–1913 and dedicated on October 24, 1913. Architect James M.A. Darrach designed this large brick building housing reading rooms, fireplaces, a grand front entrance, and a usable basement. Surrounding the building were playgrounds that included a fine double tennis court, a croquet court, a quoits court, and clock golf course. (Patricia Pelkey)

JAMES SANFORD MORGAN. A lifelong Coventry resident, James Sanford Morgan was born on December 2, 1818, and died on March 22, 1909. Owner of the Morgan Silk Mill, he served as town clerk and treasurer, as a member of the Connecticut General Assembly in 1875, and as a deacon (33 years) and choirmaster (69-plus years) of the First Congregational Church. (Ethel Harris.)

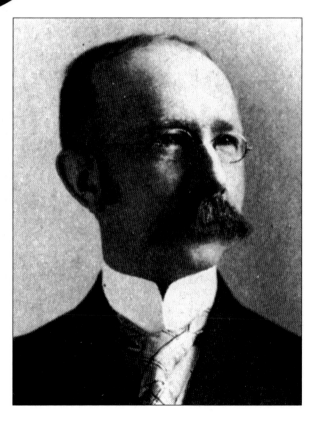

DR. WILLIAM L. HIGGINS (1867–1951). Dr. William L. Higgins graduated from New York Medical School in 1890 and settled in Coventry in 1891. In addition to serving as a general practitioner, health officer, and coroner for more than 50 years, he was a civic and political leader. He held numerous public offices on the local, state, and national levels. While a state representative, he became known as "the man who got Connecticut out of the mud" for his work on the Dirt Roads Improvement Project. A section of Route 31 in Coventry and Mansfield was named the Higgins Highway in his honor. (*Official Program, 1912 Celebration.*)

HANK KEENE. A talented country-and-western performer during the 1930s and 1940s, Hank Keene sang, played a variety of instruments, and published more than 200 pieces of original music. As noted in one of his songbooks, Hank Keene was "Born to the Theater" and came from a third-generation show business family. After attending Tufts College, where he studied music, he organized a radio program, *Hank Keene and His Gang,* starting on WTIC in Hartford. He traveled to major theaters throughout the country with his musical comedy show. By 1933, he had his own traveling tent theater. His most popular recording in 1936 was "The Last Round-Up," and his most popular composition was "The Runaway Boy." (François J. Gamache.)

THE DR. NATHAN HOWARD HOUSE, c. 1784. Dr. Nathan Howard was married to Joanna Hale, Nathan Hale's sister. The Howards likely raised their family at this location. Many years later, during the early part of the 20th century, the home was purchased by Abner and Katie Keene, parents of Hank Keene. Located at the corner of South Street and Judd Road, the house burned down in 1968. (Connecticut Historical Society.)

CAPRILANDS. Already a successful and well-traveled buyer for Steigers Department Store, Adelma Grenier and her parents purchased this 150-acre farm on Silver Street in 1929. Initially, Grenier raised goats and sold the milk. During her middle years, following a drought that killed just about everything but the herbs, she decided to pursue her growing passion for herbs and gardening. She named the farm Caprilands, which means "goat lands" in Latin. (Rose Fowler.)

ADELMA GRENIER SIMMONS (DECEMBER 1903–DECEMBER 1996). During the early years, Adelma Grenier Simmons invited friends to sample her newly developed herbal recipes and view her first garden, which had been laid out by the farmhouse door. In her book *A Garden Walk*, she described more gardens to be created "that would be harmonious together and would each depict some facet of herb growing." By the early 1950s, her reputation had grown and larger groups attended her lectures on herbs and legends, her garden walks, and her unique luncheons. During the next 45 years, she published 35 books, developed 31 gardens, and turned the farm into a showplace for herb culture and appreciation. (Yankee Magazine.)

Two
COVENTRY VILLAGE

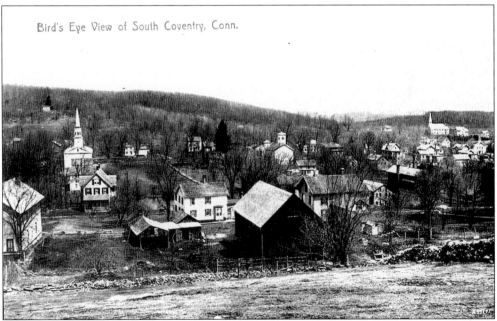

Bird's Eye View of South Coventry, Conn.

THE VILLAGE. After funds were approved in 1712, development of this area was begun and the first meetinghouse was built on a reserve lot overlooking the lake. The abundant waterpower provided by Mill Brook stimulated manufacturing along the two-mile course between Lake Wamgumbaug and the Willimantic River. Coventry Village correspondingly expanded along Main Street, paralleling Mill Brook. This *c.* 1900s view shows Coventry Village, historically part of South Coventry. (Rose Fowler.)

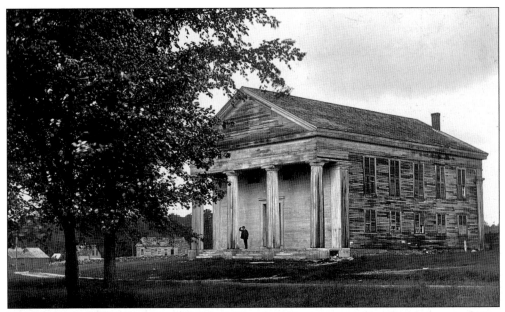

THE ORIGINAL MEETINGHOUSE. The First Church of Coventry stood on the town green facing Lake Wamgumbaug. In 1749, it was enlarged and rotated a quarter turn to face what is now the Lake Street Veteran's Memorial Green. By 1842, the building was in need of major repair. The congregation could not decide whether to improve the present church or build a new one on Main Street near the village center. A split occurred, and a new village church was erected in 1849. Union between the two churches was not achieved until January 1, 1869, and the original name, the First Church of Coventry (Congregational), was adopted. (Coventry Historical Society, Loomis Collection.)

THE DR. SAMUAL ROSE HOUSE, 1775. Samual Rose was married to Elizabeth Hale, sister of Nathan Hale. This 13-room home, facing the green, was operated as a tavern during the 1800s. Royal Rose, the last family member to occupy the home, died in 1951. A very civic-minded person, Royal Rose took pride in personally caring for the green. It was as a result of his efforts that the cannon was placed on the green in 1928. (Robert and Lois Frankland.)

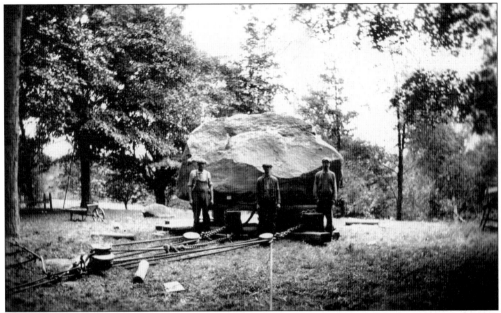

THE MEMORIAL STONE, DEDICATED IN 1928. The stone was placed on the green in memory of "those men of Coventry who gave themselves unreservedly in the hour of their country's need. Among them, Nathan Hale whose immortal last words all might have echoed." (Robert and Lois Frankland.)

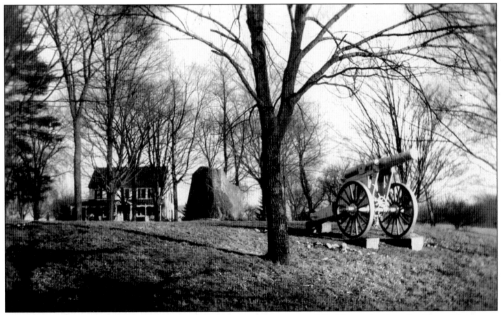

THE HISTORIC MILITARY TRAINING GROUND. Men assembled here during the Revolutionary War, the War of 1812, and the Civil War. The cannon was presented in 1928 by the U.S. government, during the administration of Calvin Coolidge. (Robert and Lois Frankland.)

A Late-19th-Century Home, Overlooking Lake Wamgumbaug. During the 1930s this was known as the Blue Lantern Inn, owned and operated by Tom Overholt. It later became part of the Salvation Army camp complex. (Coventry Historical Society, Goodin Collection.)

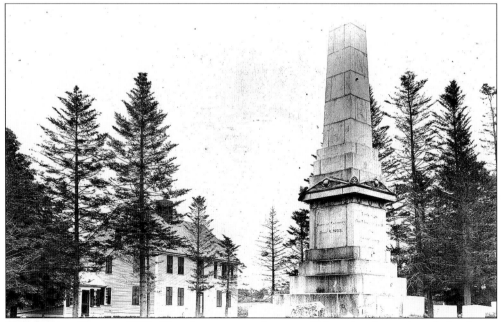

The Lyman House, 1772. This large center-chimney Colonial is located on Lake Street across from the Nathan Hale monument. In the early 1800s, it served as an inn, operated by Martin Lyman. In 1822, the South Coventry Post Office was located here, with Martin Lyman as postmaster. (Coventry Historical Society, Crickmore Collection.)

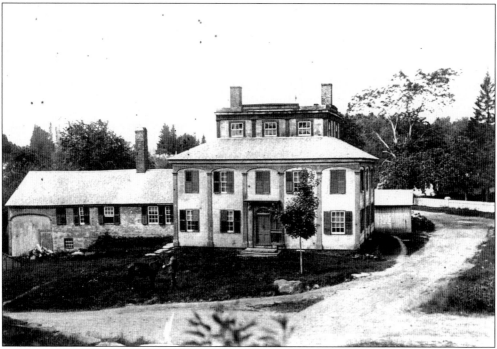

THE JOHN BOYNTON HOUSE, C. 1800. The earlier section of this home dates to 1750. According to the *1990 Historic Resources Inventory*, this is one of Coventry's few examples of the Federal style, displaying many distinctive and uncommon features. It was occupied during the 1800s by mill owner John Boynton, who was one of the town's most influential manufacturers and citizens. (Arnold Carlson.)

THE BOYNTON BARN. Only part of the stonework remains of the barn that was located directly across Main Street. The barn blew down during the hurricane of 1938, several years after this photograph with Bob Noble was taken. (Arnold Carlson.)

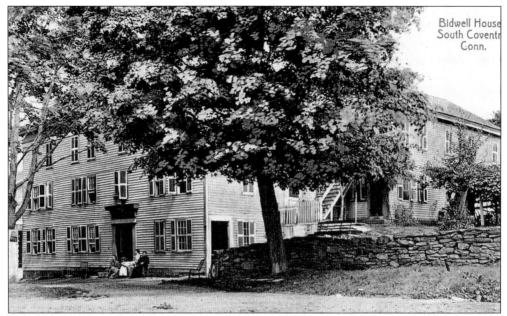

Bidwell House
South Coventr
Conn.

THE BIDWELL HOUSE-HOTEL, 1822. Built by Soloman Bidwell, the house is pictured above during the late 19th century and below during the early 20th century featuring the large barn and the addition of double porches. An advertisement from 1893 describes first-class accommodations for permanent and transient boarders and special accommodations for fishing and hunting parties, with feeding and boarding stables connected. John Payne was the proprietor. (Patricia Pelkey.)

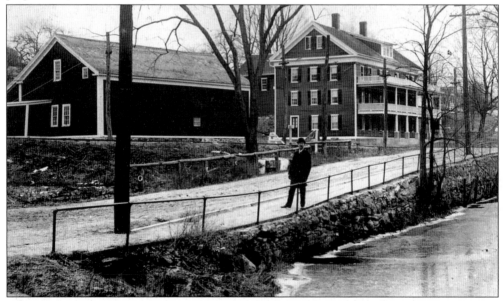

THE VILLAGE CHURCH, 1849. In 1869, the congregation reunited with the original church on the green and the original name, First Church of Coventry (Congregational) was adopted. (Rose Fowler.)

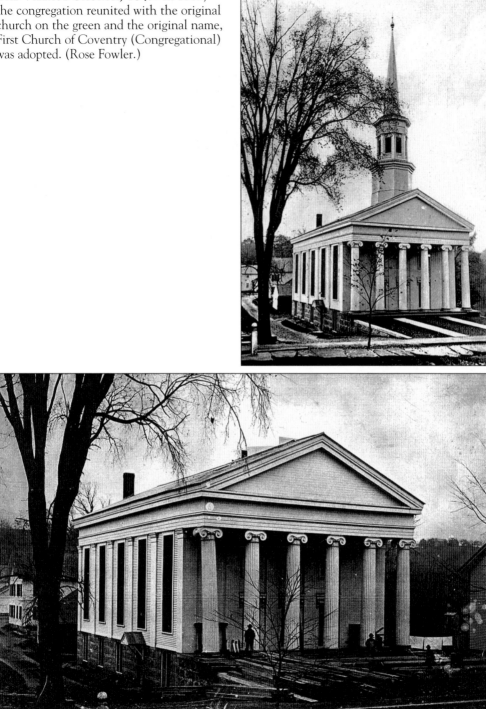

THE FIRST CHURCH STEEPLE, MARCH 1903. The steeple of the First Congregational Church was destroyed by lightning on March 19, 1903. It was repaired for the sum of $5,605.63, which was covered by insurance. (Arnold Carlson.)

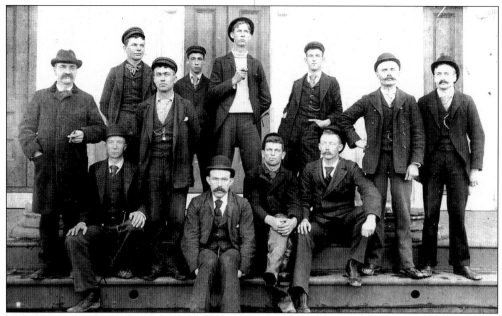

ON THE STEPS OF THE CONGREGATIONAL CHURCH, C. THE 1800S. Some men gather on the steps of the First Congregational Church. (Fred White.)

A WOMAN IN A BUCKBOARD, THE LATE 1800S. Going southeast on Main Street, this woman appears to be gathering supplies. The home in the background is a *c*. 1857 Greek Revival–style home that was the Methodist parsonage. (Coventry Historical Society, Goodin Collection.)

A VIEW OF MAIN STREET, LOOKING NORTHWEST, 1892. The *Willimantic Daily Chronicle* described this as an unusually pretty street, shaded by huge elms on both sides, with well kept lawns and very ample sidewalks. (Joy Kelleher.)

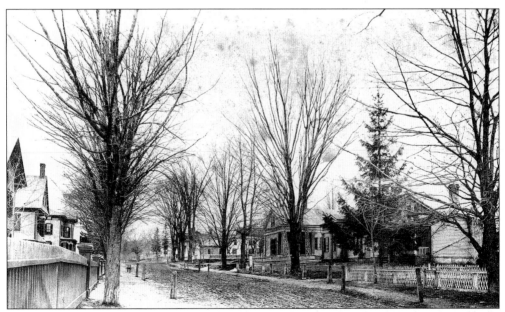

A VIEW OF MAIN STREET, LOOKING NORTHWEST, C. 1890. This photograph was taken before the trolley and telephone lines were installed. Granite hitching posts can be seen in front of each of these stately homes. (Coventry Historical Society, Crickmore Collection.)

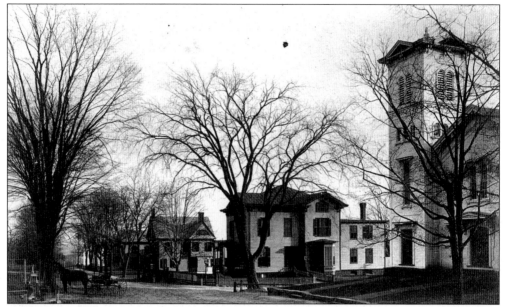

A VIEW OF MAIN STREET, LOOKING SOUTHEAST, C. 1892. The Methodist church was built at the corner of Mason and Main Streets at a cost of $1,206.91, which was raised by the Methodist Society. It was dedicated on July 17, 1867. Next to the church is the *c.* 1860s Capron-Phillips house, which served as a post office and later a drugstore. It was a central meeting place for the town. (Joy Kelleher.)

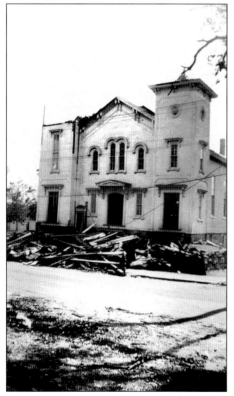

THE HURRICANE OF 1938. The destructive force of the hurricane of September 21, 1938, reduced the tallest tower of the Methodist church to a pile of rubble. (Rose Fowler.)

IKE TURNER'S GROCERY DELIVERY, C. THE EARLY 1900S. This grocery store was located on Main Street. In her book *When I Was a Girl in the Martin Box*, Orra Parker Phelps describes looking forward to Turner's butcher cart coming around once a week during the spring and summer. While his cart was tightly closed, she remembered there always being flies about. Fortunately, she did not recall there ever being any "fly-blown" meat. (Walter Jacobson.)

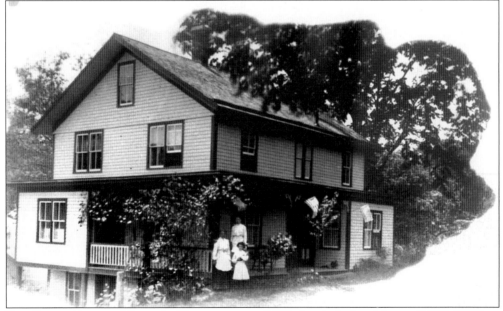

DR. LOUIS IRVING MASON'S HOSPITAL, C. 1890. Louis Irving Mason (1865–1930), a Columbia Medical School graduate, practiced medicine in New York City's St. Luke's Hospital for 10 years as a surgeon and chief of out-patients. He moved to Coventry, his father's hometown, in 1903 and practiced medicine here until 1909. He left his very successful local practice to move to larger facilities in Willimantic. (Arnold Carlson.)

31

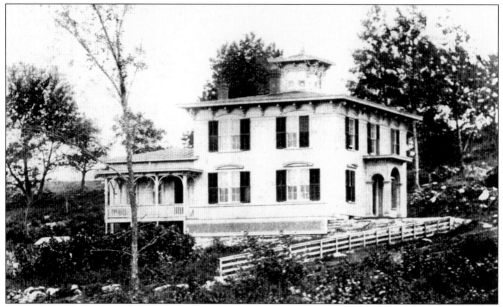

THE HENRY W. MASON HOUSE, 1860. This house is located on Mason Street just above the site of Henry W. Mason's Phoenix Metallic Cartridge Company. The home is described in the *1990 Historic Resources Inventory* as one of Coventry's excellent examples of Italianate architecture. (Arnold Carlson.)

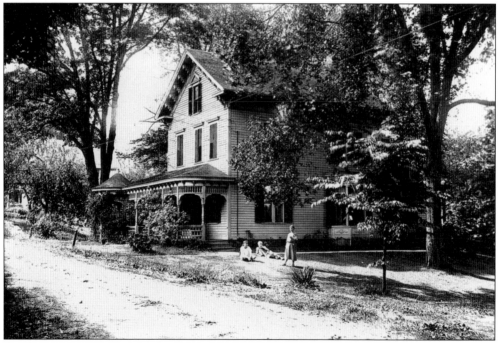

DR. LOUIS IRVING MASON'S HOUSE, C. 1890. Located on Wall Street, this house is described in the *1990 Historic Resources Inventory* as one of Coventry's excellent examples of the Queen Anne style. A bill from Dr. Louis Irving Mason, dated January 1, 1904, lists eight house calls, one office visit, and six prescriptions, for a total cost of $10.60. (Arnold Carlson.)

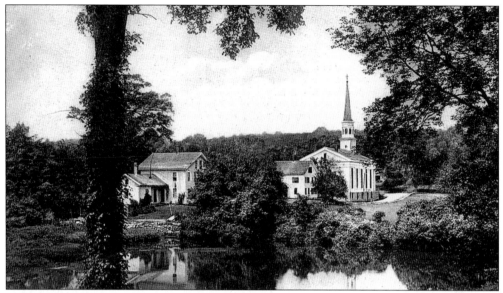

A VIEW FROM DR. LOUIS IRVING MASON'S RESIDENCE, C. 1908. Pictured are the Mill Pond and the First Congregational Church. (Rose Fowler.)

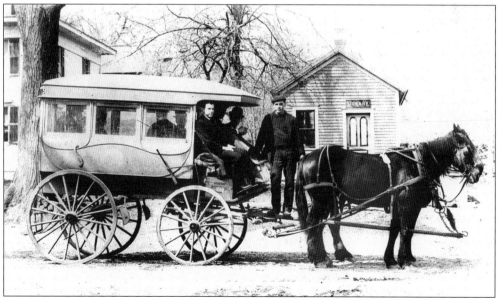

THE RAILROAD COACH, C. 1908. Driver Alfred Wright stops in front of the old library on Main Street to pick up passengers. (Charles and Fran Funk.)

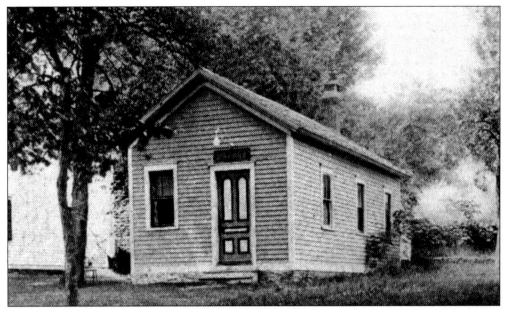

THE LIBRARY BUILDING, MAIN STREET, C. THE MID-1800S. This building was purchased by the South Coventry Library Association in 1894. It is believed to have remained open until the new Booth and Dimock Memorial Library was dedicated in 1913. The library association was formed in 1880, after a wealthy California man, Dr. Henry D. Cogswell, offered to give $500 toward the establishment of a library. Cogswell's gift was contingent on the townspeople's raising of a similar sum. As a homeless boy of 10, Cogswell had been befriended and cared for by kindly Coventry women. (Walter Jacobson.)

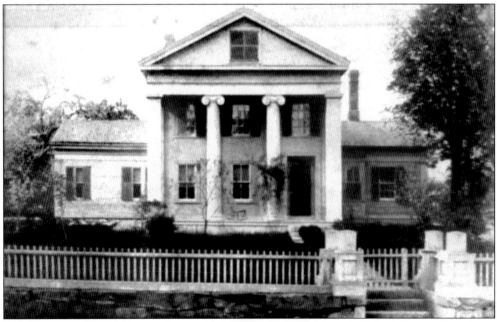

THE THOMAS CLARK HOUSE. Located on Main Street, this stately Colonial was taken down in 1911, amid controversy, to provide a site for the new Booth and Dimock Memorial Library. (Walter Jacobson.)

THE JAMES S. MORGAN HOUSE, C. 1855. This house on Main Street is described in the *1990 Historic Resources Inventory* as one of the finest examples of the Italianate style in Coventry. During the 1800s, it was the home of James J. Morgan, proprietor of the Morgan Silk Mill. (Coventry Historical Society.)

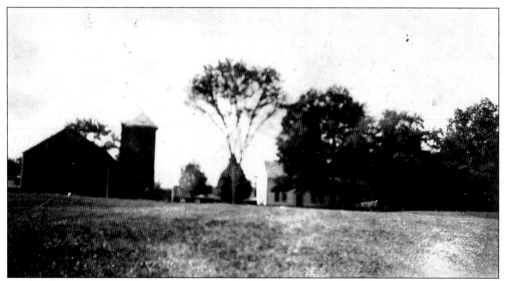

THE N.D. POTTER FARM, C. THE LATE 1800s. This farm was located on School Street across from the Center School. A blacksmith shop that made horseshoes and hinges was located on the farm. (David Mortlock.)

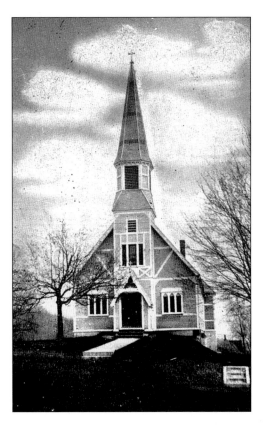

ST. MARY'S CATHOLIC CHURCH, ERECTED IN 1877. The parish consisted of some 85 families. Previously, Catholics gathered at private homes for worship. The first Mass was offered in the home of Jeremiah Crowley, and the Reverend Michael McCabe, missionary to Willimantic, was the first celebrant. (Patricia Pelkey.)

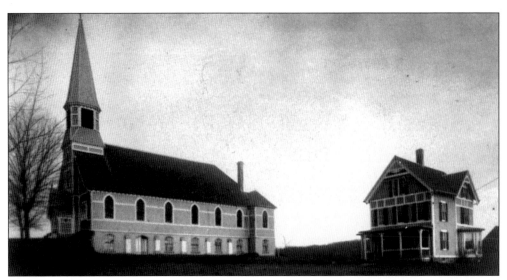

ST. MARY'S CHURCH AND RECTORY. After a larger church was built on Main Street, the old church and rectory were converted to apartments during the 1970s. The old church building was destroyed by fire in 1993. (Arnold Carlson.)

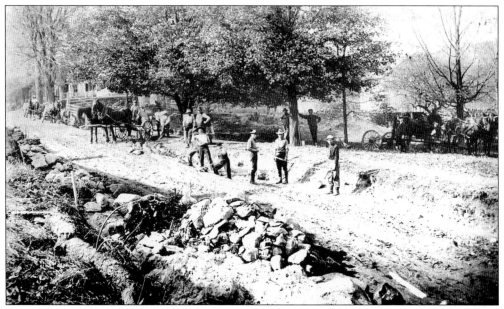

THE CONSTRUCTION OF THE SOUTH COVENTRY TROLLEY TRACKS. The extension of the Connecticut Company's line at the Willimantic Cemetery began in the summer of 1908. The 6.8-mile line ended at Lakeside Park, on the southeastern shore of Lake Wamgumbaug. (François J. Gamache.)

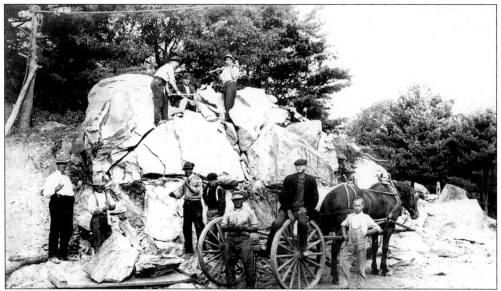

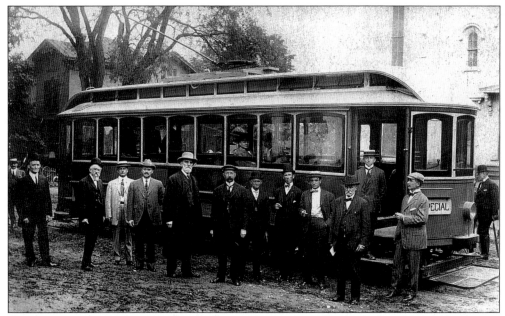

OFFICIALS ON AN INSPECTION TOUR, AUGUST 18, 1909. The day before the public opening, officials of the Connecticut Company and the Public Utilities Company made an inspection tour of car No. 104. According to the *Willimantic Daily Chronicle*, "with school and church bells ringing, flags waving and people cheering, South Coventry welcomed the official's car which rolled into the village on the rail of the new Trolley line between 12 and 1 o'clock this after noon." (François J. Gamache.)

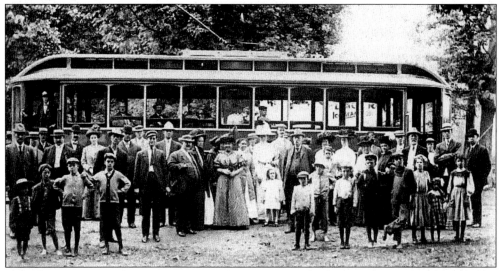

THE TROLLEY LINE OPENS IN SOUTH COVENTRY, AUGUST 19, 1909. On this day the Willimantic-South Coventry Trolley line was opened to the public with a fare of 10¢ each way. According to the *Willimantic Daily Chronicle*, the trolley was well patronized, and by afternoon, there were more people than the car could handle. The *Chronicle* noted that the trolley would provide easy access for the people of Willimantic and other cities to the charming village of South Coventry and the beautiful lake, already known as an ideal vacation destination. (François J. Gamache.)

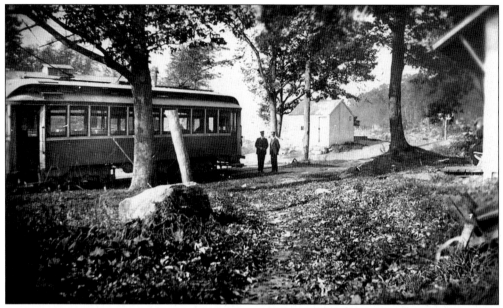

A VIEW OF THE TROLLEY, C. 1912. The trolley at Lakeside Park awaits passenger for the return trip to Willimantic. (Robert and Lois Frankland.)

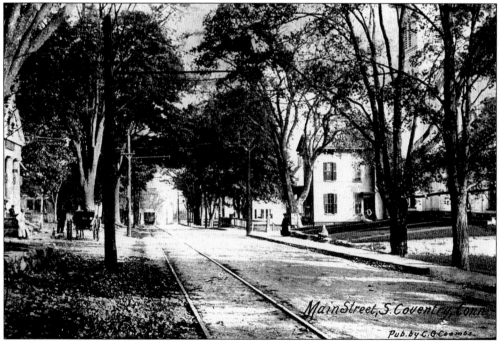

A VIEW OF MAIN STREET, LOOKING SOUTHEAST, C. 1912. The trolley heads up the tracks. A horse and buggy is parked in front of the W.L. Wellwood General Store on the left. (Patricia Pelkey.)

THE BIG ELM, NEAR POST OFFICE, S. COVENTRY, CONN.

THE MEETINGHOUSE TREE, MASON STREET, C. 1912. The large elm in the middle of Mason Street was known as the Meetinghouse Tree because notices were nailed to the tree informing the townspeople of local news and events. The tree fell during the hurricane of 1938. This was a busy intersection at the time, with the post office to the right in the Capron-Phillips House (not shown) and the library and the Wellwood Store located across Main Street. (Rose Fowler.)

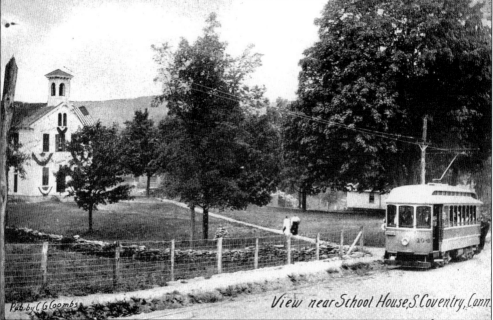

View near School House, S. Coventry, Conn.

A TROLLEY PASSING THE CENTER SCHOOL, MAIN STREET, C. 1912. Trolley service in Coventry was discontinued in 1926 to make way for the new bus service and increasing automotive traffic. The tracks were removed in 1927. (Patricia Pelkey.)

HOMES AT THE CURVE. This *c.* 1780 Colonial and this *c.* 1920 home contribute to the dramatic entryway to the village. The 1920 building served as a store run by J.B. Carmon and a meeting place for the Men's Social Club. Following the repeal of Prohibition, it became Coventry's first tavern, operated by Frank Parker, to sell the permitted "3.2 beer." (Coventry Historical Society.)

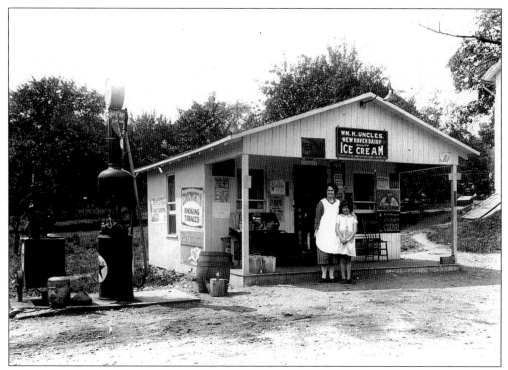

THE ICE-CREAM SHOP AND FILLING STATION. Billy Uncles owned and operated this store on the right side of Main Street, near what is now Genzyme. (Arnold Carlson.)

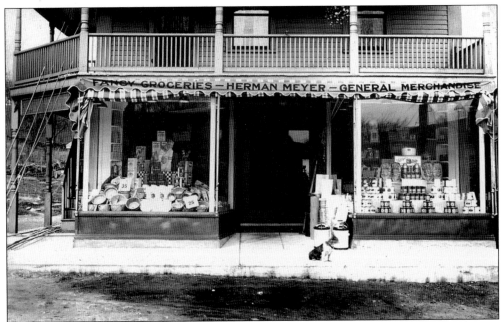

HERMAN MEYER'S STORE, MAIN STREET, APRIL 21, 1928. Herman Meyer sold fancy groceries and general merchandise, according to the sign above the store. (Robert and Lois Frankland.)

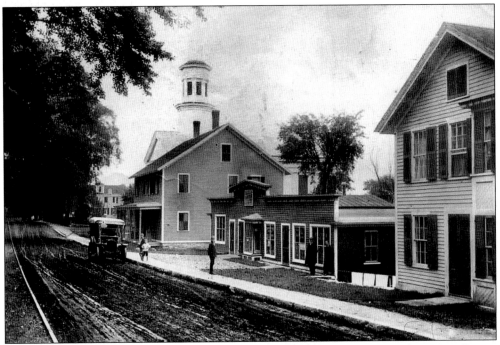

J.S. CHAMPLIN'S BARBERSHOP, POOL PARLOR, AND STORE, C. 1920. Located on Main Street, this establishment offered a variety of conveniences, including a filling station at one time. The First Congregational Church is seen in the background. (Walter Plowman.)

ICE-CREAM CONES, C. THE 1920S. Among the pleasures that Champlin's store provided were ice-cream cones. (Robert and Lois Frankland.)

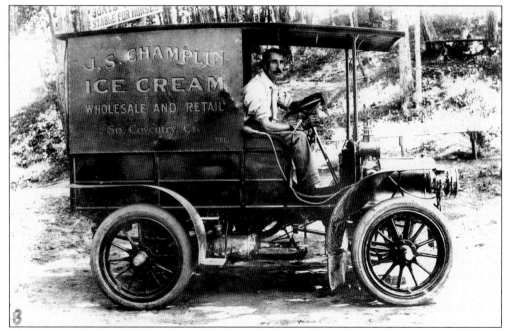

J.S. CHAMPLIN'S ICE-CREAM TRUCK, C. THE 1920S. John Champlin sits at the wheel of his ice-cream truck. (Arnold Carlson.)

THE TOWN OFFICE BUILDING, 1876. This brick structure, built in the Victorian Vernacular style, was opened during the nation's centennial year. It remained in use as the town office building until 1929, when the town took over the bankrupt Tracy-Elliot Mills and moved into the larger office facility, now the Bidwell Tavern. (Town of Coventry.)

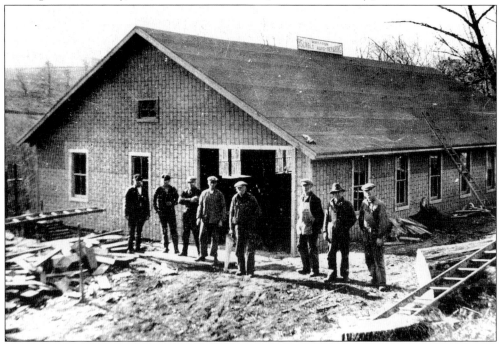

FRINK'S GARAGE, 1922. Located on Main Street, Frink's garage was owned and operated by Henry Frink. (Coventry Historical Society, Goodin Collection.)

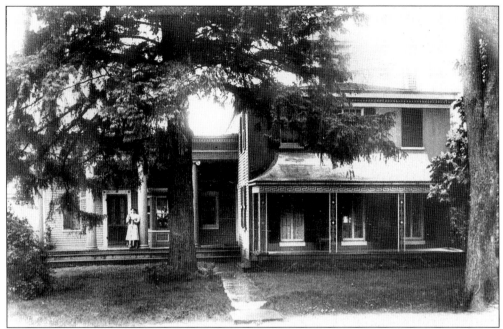

THE WASHBURN HOUSE, C. THE 1920s. The Washburn home was located on Main Street next to the Methodist church. The town burned the building in the early 1960s to make way for a parking lot. (Arnold Carlson.)

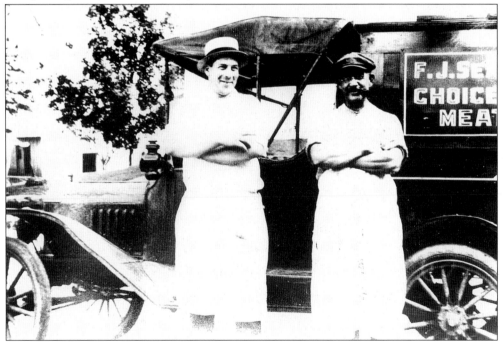

THE F.J. SEARS MEAT MARKET, C. THE 1920s. Deliveries from this Main Street establishment were made in the market's Model T Ford. Originally located in the two-story tenement house, the meat market later moved to the lower level of the Wellwood Store. (Coventry Historical Society, Goodin Collection.)

A View of Main Street, Looking Southeast. The *c.* 1887 A.W. Wellwood Store, on the left, was the earliest store in the village center. It was originally owned by N.P. Loomis. Next to it is the Booth and Dimock Memorial Library, dedicated on October 24, 1913. (Coventry Historical Society.)

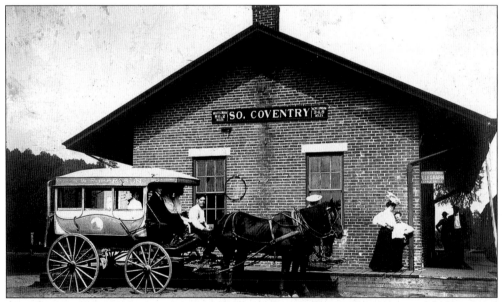

The Railroad Depot, Station No. 7. The New London, Willimantic, and Palmer Line train service began in Coventry *c.* 1850, contributing to the industrial growth of the town. The station was located on Depot Road, a center of commercial activity until the Rawitzer Mills burned in 1879. Passenger coach service ran from the station to the Bidwell House. Pictured is Mr. Robertson's coach. (Rose Fowler.)

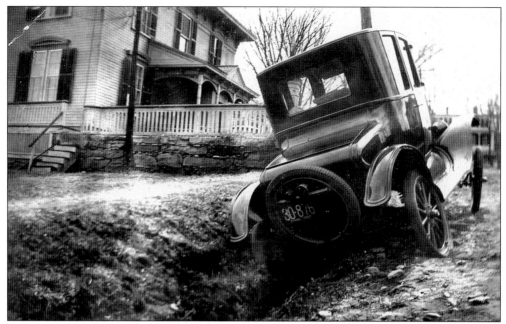

A FORD MODEL T COUPE, APRIL 4, 1925. This accident occurred in front of the Henry Mason House, at the corner of Mason and Wall Streets. (Robert and Lois Frankland.)

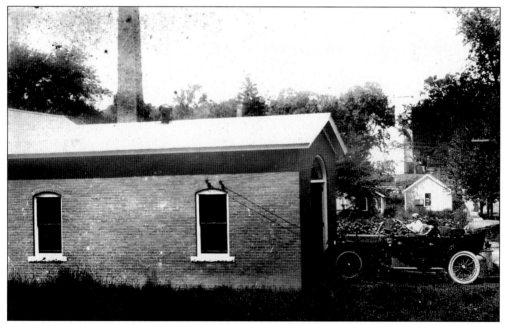

THE KINGSBURY HOUSE GARAGE, C. THE EARLY 1900S. This brick garage was built by Addison Kingsbury for his new Packard. Pictured is Henry Frink, who was the driver for Addison Kingsbury's son Louis Kingsbury. (Sandy Sanborn.)

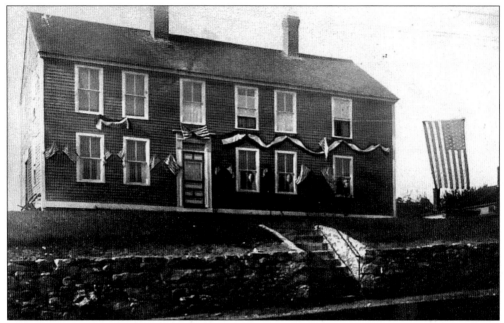

MILL HOUSING. Decked out for the 1912 bicentennial celebration, this home—once 18th-century mill housing—is located on Main Street across from School Street. (Walter Plowman.)

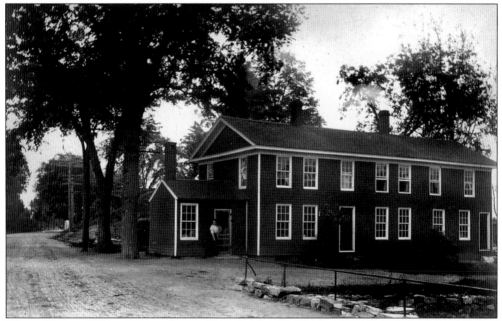

MILL WORKERS' HOUSING, C. 1860. This early example of mill workers' housing is believed to have been part of Barber's Village, an area that provided housing for workers from the Kenyon Mill. (Coventry Historical Society.)

THE E.A. TRACY HOUSE, C. THE EARLY 1900S. Located on Prospect Street, this home was once owned by the Tracy family, who ran the E.A. Tracy Wool Extraction and Shoddy Mill. (Robert and Lois Frankland.)

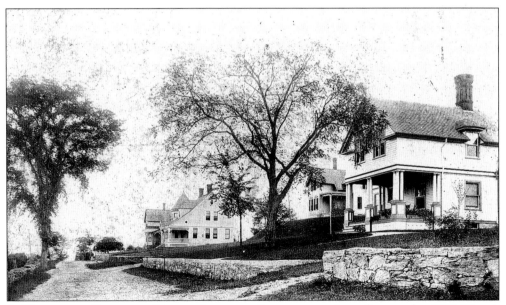

A VIEW FROM PROSPECT STREET, LOOKING SOUTHWEST. According to the *1990 Historic Resources Inventory*, the *c.* 1900 home on the right is a transitional Queen Anne Colonial Revival style. (Coventry Historical Society, Crickmore Collection.)

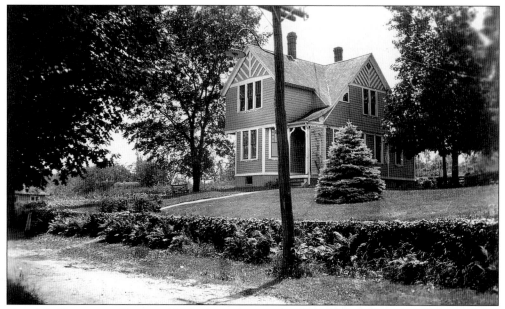

THE J.S. CHAMPLIN HOUSE, 1890. According to the *1990 Historic Resources Inventory*, this home is a good example of a well-executed Queen Anne–style house. This was the former residence of J.S. Champlin. (Robert and Lois Frankland.)

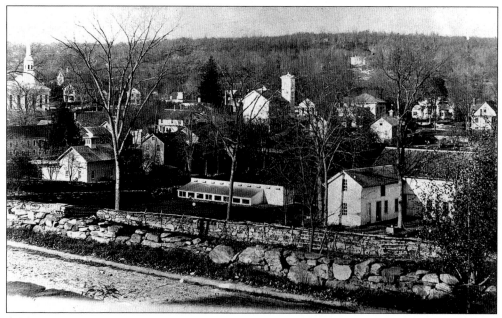

A VIEW FROM PROSPECT STREET, NOVEMBER 1947. The long, low building in the foreground was the greenhouse owned by the Kingsbury family. (Arnold Carlson.)

Three

INDUSTRY ALONG MILL BROOK

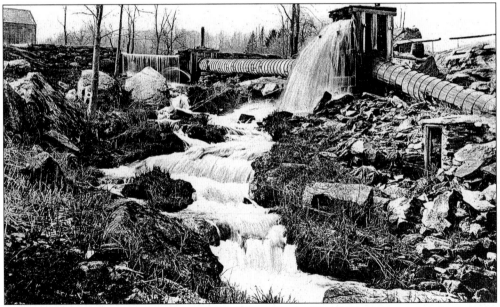

THE PENSTOCK AT THE T.H. WOODS MILL. The village of South Coventry, as it is historically known, grew and prospered during the 19th century because of the abundant waterpower along Mill Brook. Mill Brook flows along a two-mile course from Lake Wamgumbaug to the Willimantic River, dropping a total of 250 feet along the way. The concentration of water mills that developed within this short distance resulted in South Coventry becoming one of the most vital small mill villages in New England. In recognition of this significant industrial history and the historic and architectural resources of the village, on May 6, 1991, the South Coventry Historic District was placed on the National Register of Historic Places. (Patricia Pelkey.)

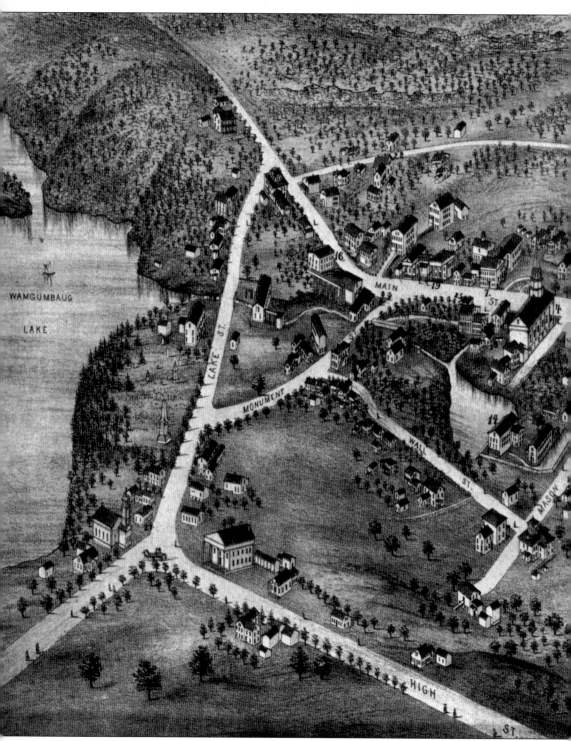

A View of South Coventry, an 1878 Map. In addition to the abundant waterpower, the arrival of the railroad in 1850 contributed to the industrial growth of the village. A total of 17 mills were operating along Mill Brook at its peak and, unlike many small mill towns, one

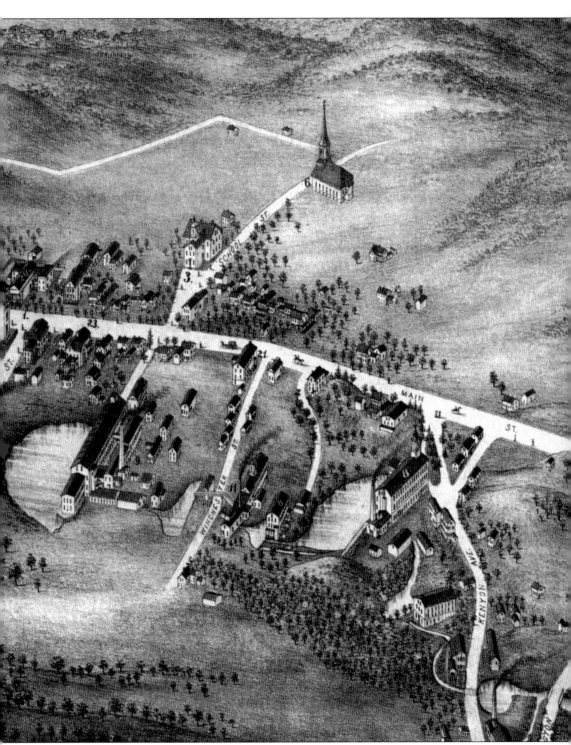

product or manufacturer did not dominate. Industries included grist, carding, and textile mills, and the production of paper, paper boxes, cartridges, windmills, and wagons.

THE FIRST WATERPOWER PRIVILEGE, LAKE STREET. John Boynton operated a wool-carding mill on this site from 1815 to 1855. He also developed and manufactured carding machines. Other mills at this location have been the Halladay Windmill Factory (1855–1863), Crittendon and Tibbals Ammunition Factory (1863–1865), the Clark Twine Factory (1865–1875), the White-Standley Flour Factory (1875–1905), the Woodworth Horseshoe Shops and Cider and Vinegar Factory (1905–1945), and the Tremont Fix-It Shop (1945–1984). (Patricia Pelkey.)

THE SECOND WATERPOWER PRIVILEGE, MAIN STREET. In 1716, the town arranged with Jonathan Hartshorn to "erect a good and proper grist mill" for grinding the settler's corn. The town's first mill was later sold to T.E. Porter. In 1869, Daniel Green was operating a shoddy mill, along with the gristmill. By 1878, N.B. Bessey and Company was making "bed comfortables." Before the beginning of the 20th century, Thomas H. Wood was producing silk and silk fishing line. Deknatel began producing surgical thread at this location in 1956, and during the late 1990s, ownership was transferred to the Genzyme Corporation. (Patricia Pelkey.)

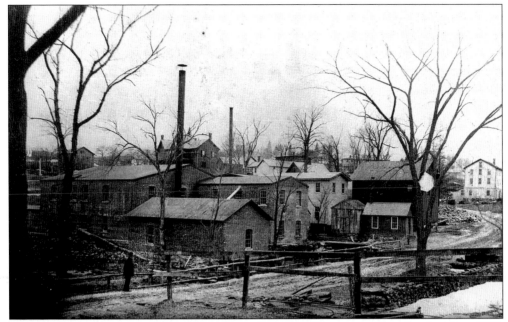

THE THIRD WATERPOWER PRIVILEGE, MAIN STREET. This site was first developed in 1815, when Solomon Gilbert opened a paper mill. In 1830, it was sold to Dikes and Sabin, who operated a cotton mill. The E.A. Tracy Wool Extract and Shoddy Mill operated at the complex, consisting of as many as 15 buildings, from 1880 to 1929. Used fabrics were reprocessed for the production of inexpensive woolen cloth called shoddy. (Patricia Pelkey.)

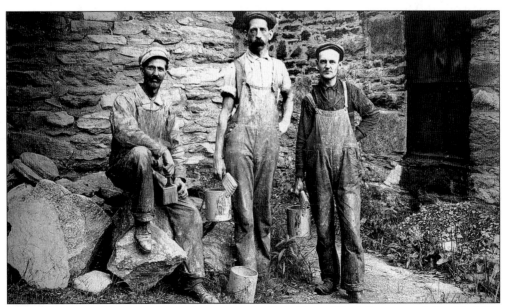

MILL WORKERS. Shown is the work crew at the E.A. Tracy Wool Extract and Shoddy Mill. (Coventry Historical Society.)

THE FOURTH WATERPOWER PRIVILEGE, MAIN STREET. Ebenezer Bacon had a small mill on this site *c.* 1828 for fulling and dressing cloth. A foundry was built in 1840 by Smith and Washburn. Next, Crittendon and Tibbals manufactured percussion paper caps here. The A. Washburn and Son Silk Mill was the last mill to be built on this location; it was destroyed by fire. (Patricia Pelkey.)

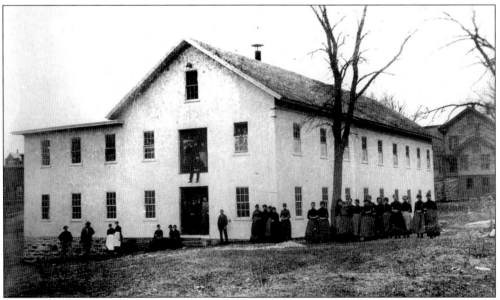

THE FIFTH WATERPOWER PRIVILEGE, MASON STREET. A sawmill occupied this site until 1865, when Walter Loomis constructed a silk mill. This mill was sold to J.S. Morgan in 1873 and operated as the Morgan Silk Mill until it was sold to Albert Bottum in 1883. In the 1930s, the mill was again sold and operated under the name of Dady's Silk Mill until purchased by the National Silk Company, owners of Tioga Yarn. Pictured here is Bottum's Mill and its workers *c.* the 1800s. (Patricia Pelkey.)

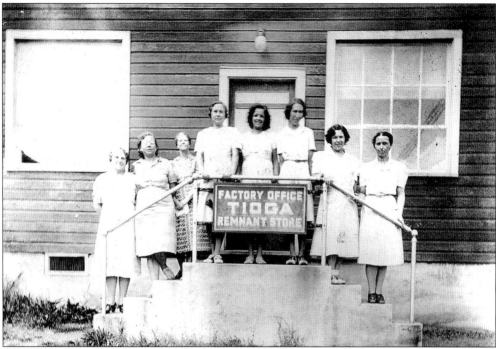

OFFICE WORKERS. Workers pause on the steps of the National Silk Company's Tioga Yarn Factory Office and Remnant Store *c.* the 1930s. Corinne Pender is identified as the fourth from the left. (Charles and Fran Funk.)

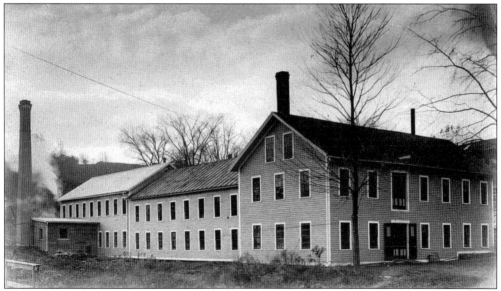

THE SIXTH WATERPOWER PRIVILEGE, MASON STREET. In 1868, Addison Kingsbury built the Kingsbury Box and Printing Company. Kingsbury developed machines for cutting, gluing, and folding. He was considered one of the most successful paper box manufacturers in New England. By the start of the 20th century, in addition to South Coventry, he had factories in Rockville, Willimantic, New London, and Northampton, Massachusetts. His son Arthur Kingsbury joined the company in 1883. (Rose Fowler.)

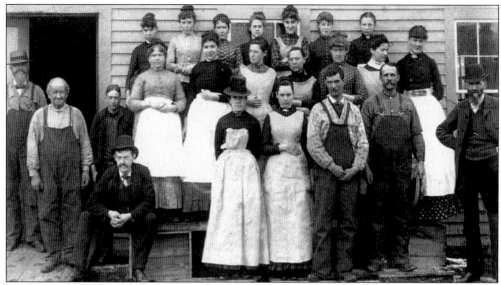

FACTORY WORKERS. Shown *c.* the early 1900s are workers at the Kingsbury Box and Printing Company. (Coventry Historical Society.)

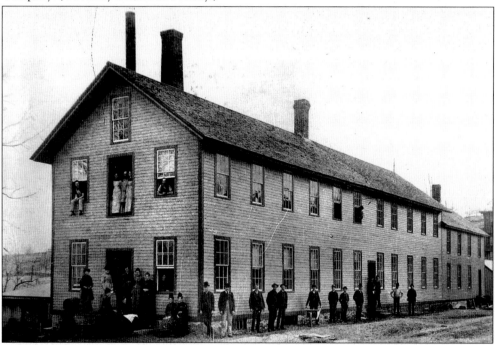

THE SEVENTH WATERPOWER PRIVILEGE, MASON STREET. During the 1850s, Henry W. Mason joined Walter A. Loomis in forming the Loomis and Mason Hook and Eye Manufacturers. The Civil War provided Mason with an opportunity, and the Phoenix Metallic Cartridge Company Partnership was formed. Mason's manufacture of small arms was distinctive "because it spanned three different types of cartridges and was the only manufacturer to successfully make the transition to metallic center fire cartridges," according to Terry A. White, who wrote about Mason in 1995. Later, William F. Wood and Sons operated an optical goods company at this location, and in 1925, the building burned. (Patricia Pelkey.)

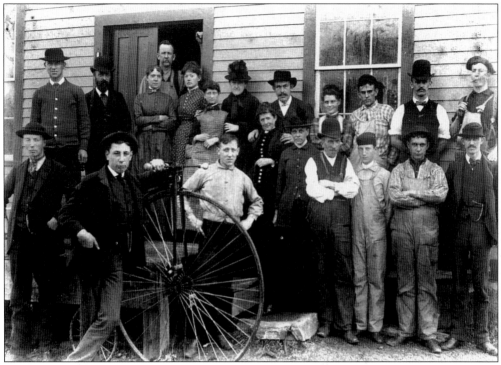

FACTORY WORKERS. Shown are workers at the Phoenix Metallic Cartridge Company, owned by Henry A. Mason and Company. John Champlin is pictured with his high cycle. (Arnold Carlson.)

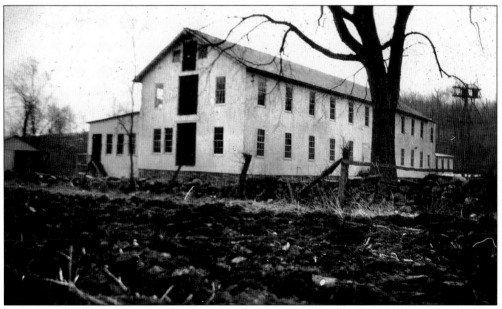

THE EIGHTH WATERPOWER PRIVILEGE, WOODS LANE. This site was used for the production of textiles. Pictured is the Globe Mill on April 15, 1927. Parachute cords were being produced by the Burkamp Mill when the building burned down in 1942, during World War II. (Robert and Lois Frankland.)

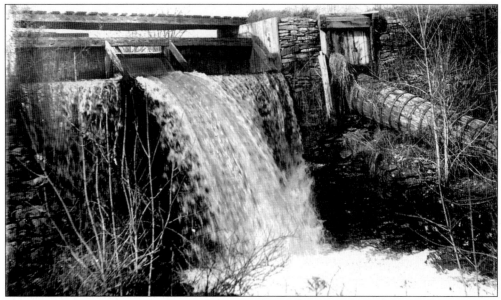

THE SPILLWAY AT GLOBE MILL. Shown is the spillway at the Globe Mill. (Coventry Historical Society.)

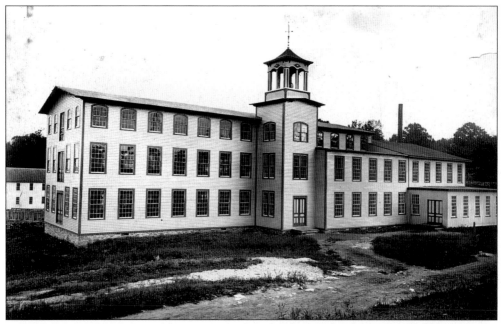

THE NINTH WATERPOWER PRIVILEGE, WOODS LANE. Capt. Nathaniel Durham owned a cotton mill on this site *c.* 1830. It burned about 10 years later, and Leander Boynton, son of John Boynton, built a small woolen mill, which he leased. The mill was later sold to William Bradbury and, in 1876, was under the ownership of J.M. Woods Woolen Manufacturer. (Arnold Carlson.)

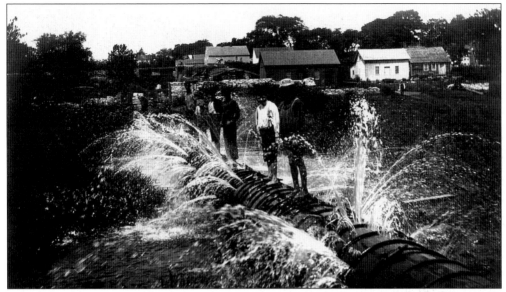

THE SLUICEWAY AT THE J.M. WOODS WOOLEN MILL, THE C. LATE 1800S. Shown is the sluiceway at the J.M. Woods Woolen Mill. (Coventry Historical Society.)

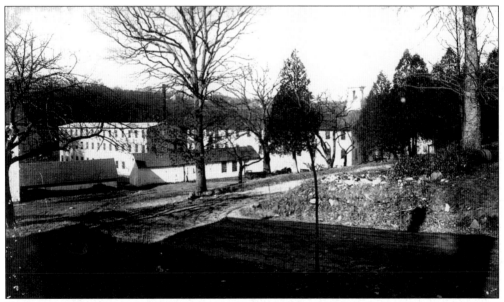

THE 10TH WATERPOWER PRIVILEGE, ARMSTRONG ROAD. Newton Dow, Edward Matheson, and Augustus Strong built a large mill here c. 1840 for the production of wood cards. By the 1850s, the mill was owned by Kinsman Johnson, who operated a tannery. Later, Samuel Murdock manufactured woolen goods at this location. The building burned two times and was not rebuilt the second time. In 1864, the property was sold to Charles H. Kenyon, who erected a large woolen mill. Upon his death, it was sold to E.A. Tracy, who ran the E.A. Tracy Valley Mill for many years. (François J. Gamache.)

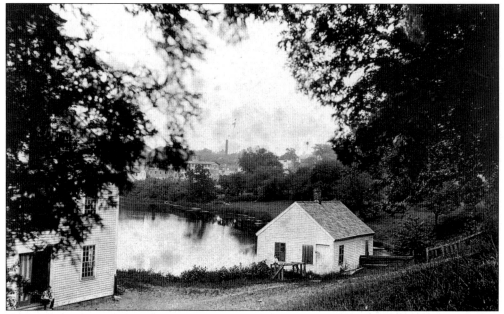

THE POND AT THE KENYON WOOLEN MILL, C. THE EARLY 1900S. Shown is the pond at the Kenyon Woolen Mill. (Coventry Historical Society.)

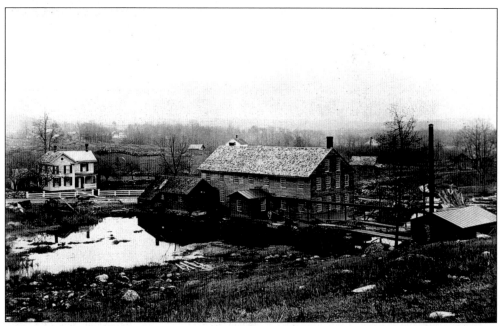

THE 12TH WATERPOWER PRIVILEGE, ARMSTRONG ROAD. In 1844, Elija Robertson built a small factory for making cotton batting and rented a section for the manufacture of wool hats. By 1860, the mill was sold to J.N. Dow, who expanded the facility for the manufacture of carding machines. The mill then passed to Henry Parker, who sold it to Henry Armstrong. The Armstrong Wagon Shop, manufacturer of wheels, spokes, hubs, wagons, and carriages, continued to operate into the early 20th century. The house to the left was the home of the White family during the early 1920s. (Walter Jacobson.)

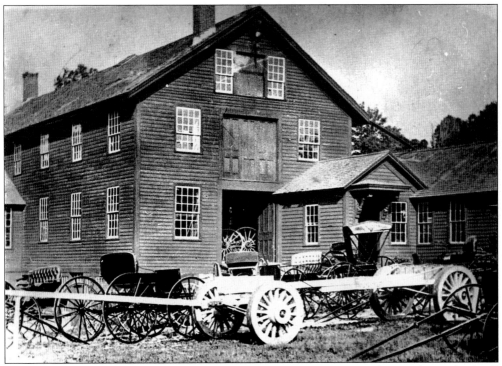

THE ARMSTRONG WAGON SHOP. A receipt dated March 21, 1906, lists spoking wheels all round and setting tires for a cost of $3.40. (Coventry Historical Society.)

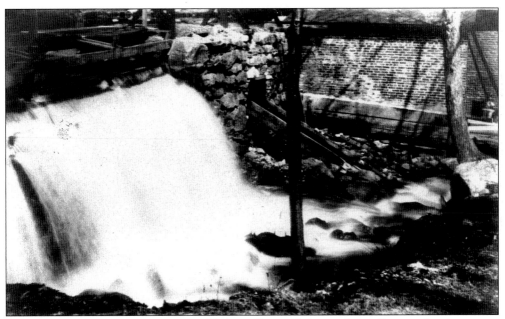

THE SPILLWAY AT THE ARMSTRONG WAGON SHOP. Shown is the spillway at the Armstrong Wagon Shop. (Arnold Carlson.)

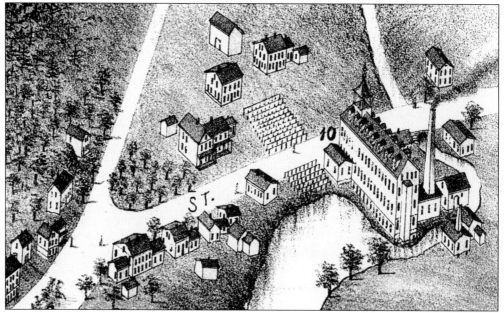

THE 13TH WATERPOWER PRIVILEGE, DEPOT ROAD. The Coventry Satinet Company was formed by Ebenezer Root, Thomas Stebben, and John Boynton *c.* 1830. During the next 30 years, the mill passed to Alvin and Nelson Kingsbury, then to John Boynton, and finally to Horace Fargo, who operated it until he died in the 1860s. By 1868, Rawitzer Brothers Woolens was extensively involved in the manufacturing business at this site. The mill burned *c.* 1885. Another building was erected, and for a time, the Eden and Company Woolens Mill was in operation. In 1947, the Stirling Fiberboard Company was at this location. (Arnold Carlson.)

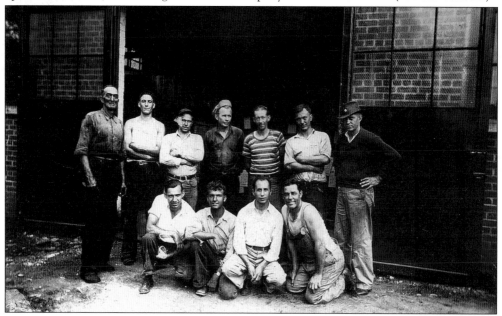

A WORK CREW, 1947. Pictured are the workers at the Stirling Fiberboard Company. Ray Pender is at the lower left. William Crooks, second row on the right, was a well-known banjo player who published an instructional book for playing the banjo. (Charles and Fran Funk.)

Four
Lake Wamgumbaug (Coventry Lake)

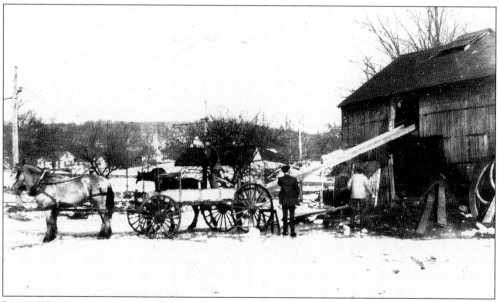

Lake Wamgumbaug. This lake, now referred to as Coventry Lake, is the largest lake in northeastern Connecticut, covering about 400 acres. Entirely spring fed, Lake Wamgumbaug has been one of Coventry's most valuable assets since Colonial times, when it was a prime area for hunting and fishing. During the 19th century, industry flourished, using waterpower from the lake outlet. By the beginning of the 20th century, the lake's quiet beauty had been discovered. Lake Wamgumbaug has been a center for recreation ever since. The photograph shows ice being harvested at Wolfe's Ice House, currently the site of the Lakeside Cafe. (Patricia Pelkey.)

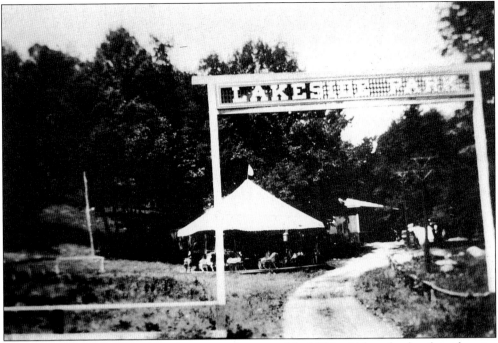

CELEBRATING THE TROLLEY'S ARRIVAL, AUGUST 19, 1909. Although already a favorite recreational spot, the installation of trolley service from Willimantic to Lakeside Park made Lake Wamgumbaug an even more popular and accessible destination. The entire town celebrated with speeches, a band concert, dancing, picnics, boat rides, and fireworks. (Robert and Lois Frankland.)

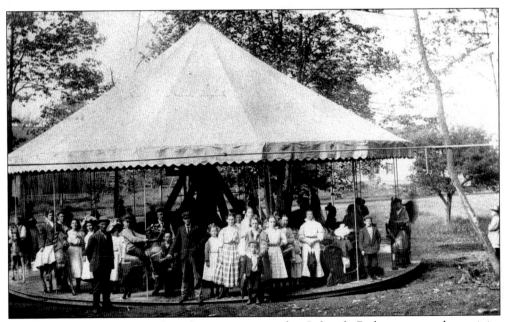

THE MERRY-GO-ROUND. Riding the merry-go-round at Lakeside Park was a popular activity for all ages. (Arnold Carlson.)

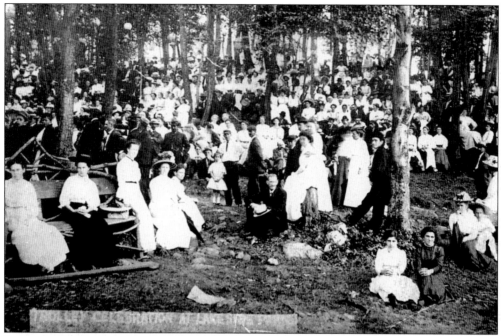

LAKESIDE PARK. Crowds gathered at Lakeside Park for the festivities celebrating the arrival of the trolley. The park was situated on the shore of Lake Wamgumbaug in a lovely grove of chestnut trees. Paths were laid out leading to the boat launch, and rustic benches were provided throughout the area. (Rose Fowler, Arnold Carlson.)

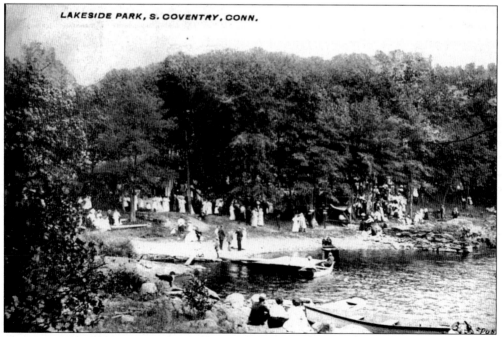

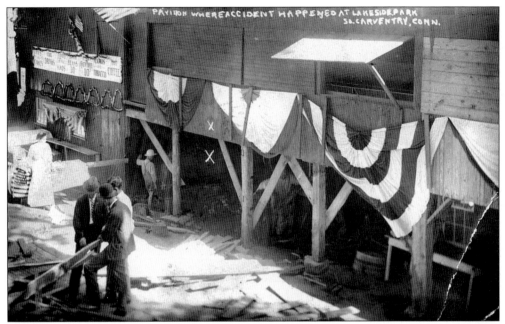

THE COLLAPSE OF THE LAKESIDE PAVILION DANCE FLOOR. The *Willimantic Daily Chronicle* reported on the day following the trolley opening, "festivities were marred late in the evening when a section of the floor of a dancing pavilion on the shore of Lake Wamgumbaug fell in while crowded with dancers. Sixteen persons were injured more or less seriously." (Arnold Carlson.)

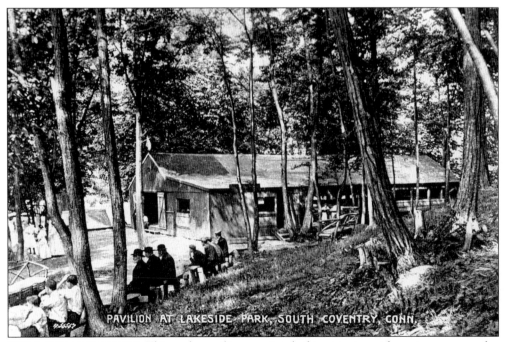

THE LAKESIDE PAVILION. This early pavilion consisted of two stories with an ice-cream parlor and a bowling alley on the first level and a hall for dancing on the second level. (Patricia Pelkey.)

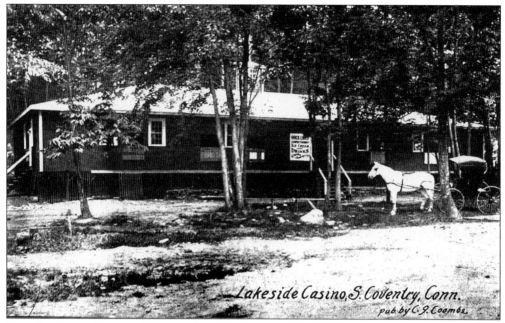

THE LAKESIDE CASINO. Built on the same site, this structure replaced the earlier pavilion. Dances were held here and during the 1930s and early 1940s, with big-name bands such as Sammy Kaye (July 1, 1938) and Jimmy Dorsey (May 30, 1939) playing at this location. At that time, the casino was owned by the Catholic Church. Weekly bingo games were held, and the band contracts were signed by Father Charles Kelly. In later years it became Sholes Lakeside Casino and was advertised as New England's largest summer roller rink. (Rose Fowler.)

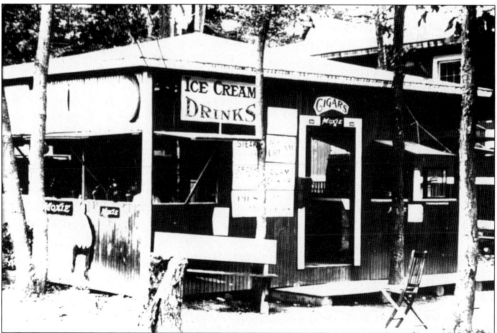

REFRESHMENTS AT THE LAKE. This small building, located between the Lakeside Casino and Woodland Road, served refreshments. (Coventry Historical Society.)

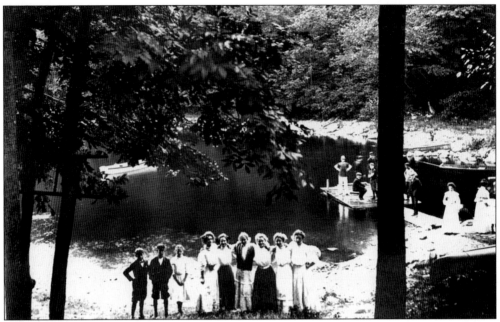

THE SHORE OF LAKE WAMGUMBAUG. This early-1900s view shows visitors gathered by the boat launch area of Lakeside Park. (David Mortlock.)

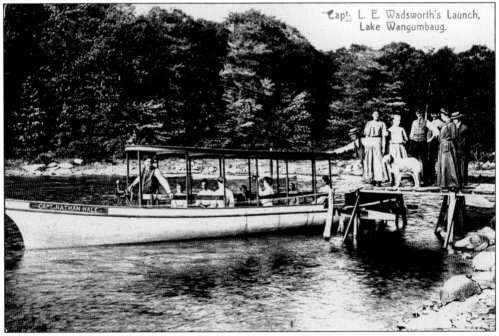

EXCURSION BOATS. The *Captain Nathan Hale* was one of four excursion boats that operated from the boat launch at the Lakeside Pavilion during the early 1900s, according to the June 15, 1996 issue of the *Willimantic Daily Chronicle*. The *Captain Nathan Hale* carried about a dozen passengers on a leisurely tour around Lake Wamgumbaug. The operation was owned by L. Wadsworth. (Rose Fowler.)

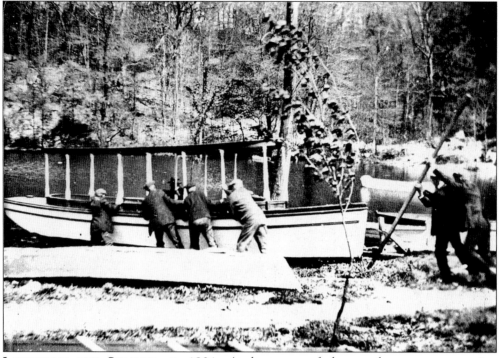

LAUNCHING THE STEAMER, C. 1921. At least one of the popular steamer excursion boats continued to operate at Lakeside Park during the 1920s. These boats were powered by steam generated by burning coal and, later, gasoline. (Coventry Historical Society, Goodin Collection.)

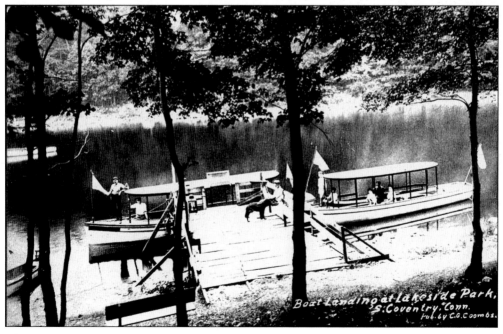

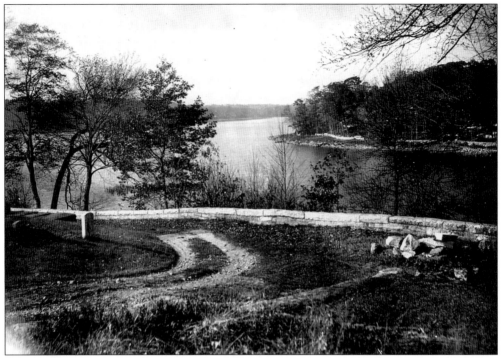

A SCENIC VIEW OF THE LAKE, C. 1917. This picture was taken at the lower end of Nathan Hale Cemetery, which is situated near the shore of Lake Wamgumbaug. The cemetery contains headstones dating back to 1735 and includes some of Coventry's most notable citizens. (Arnold Carlson.)

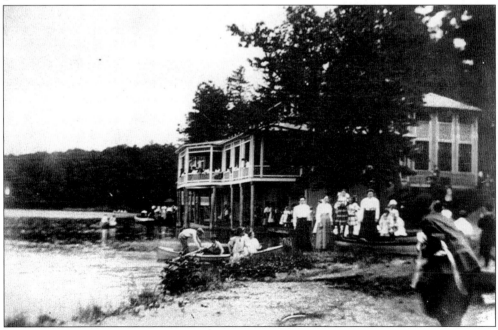

BROOKS CASINO. Located at Northeast Shores, Brooks Casino was a popular place for dancing during the 1920s. It has since been converted into a private home. (Arnold Carlson.)

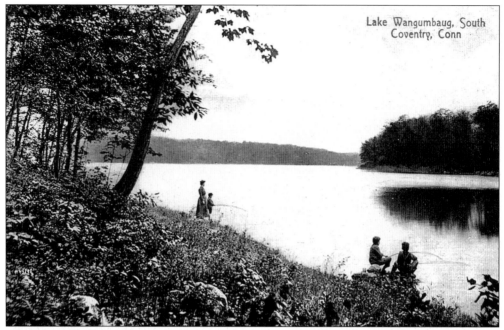

A QUIET TIME BY THE LAKE. Many spots for fishing and relaxation could be found that were apart from the activities at Lakeside Park. (Rose Fowler, Patricia Pelkey.)

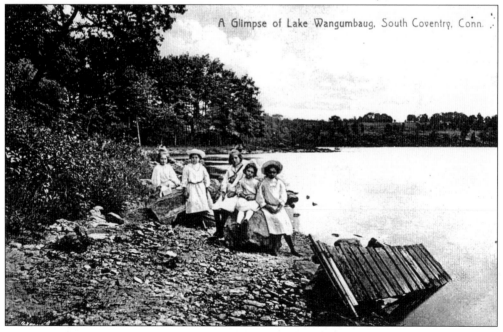

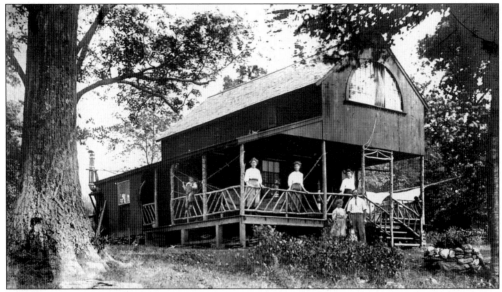

NORTHEAST SHORES. Walnut Grove cottage, *c.* 1907, and Day's cottage, *c.* 1911, were located on Northeast Shores near Woodland Road. Some cottages were passed down in families for generations; others were rented by the week, month, or for the season. Facilities were primitive even into the 1920s, with no plumbing or electricity. (Rose Fowler, Patricia Pelkey.)

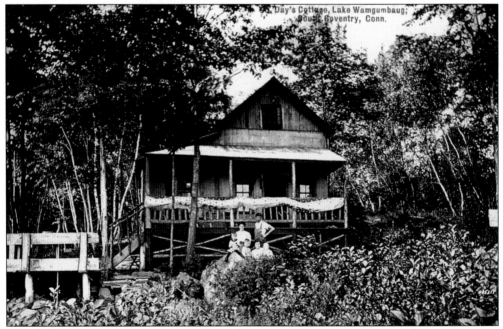

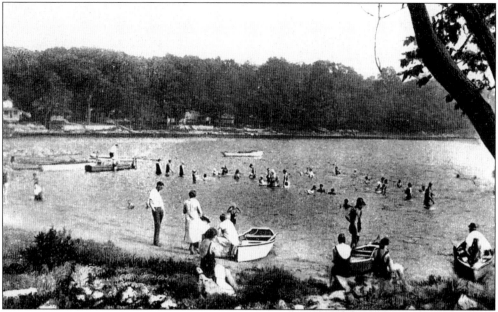

BEVILLE'S BATHING BEACH AND COTTAGE, C. 1915. This bathing beach was located on Route 31 across from the Clark (Beville) Homestead. This is now the location of Lisicke Beach. The Bevilles also had a rental cottage next to the beach area. (Rose Fowler.)

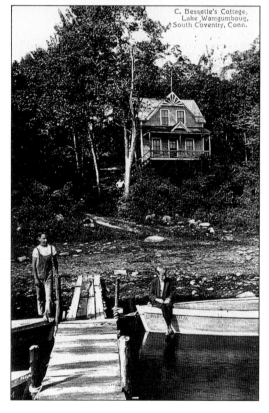

C. Bessette's Cottage, Lake Wamgumbaug, South Coventry, Conn.

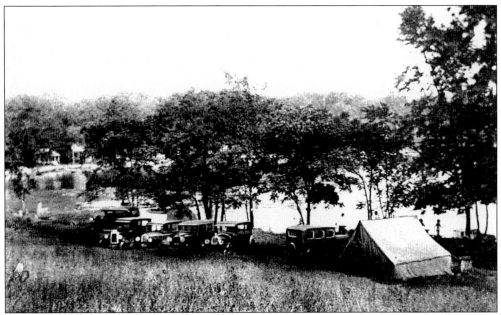

THE BEVILLE'S TOURIST CAMP AND STEAMBOAT LAUNCH. Situated adjacent to the beach was the tourist camp owned by the Bevilles. This was developed to accommodate the arrival of the automobile, making it possible for more people to enjoy the pleasures of the lake. The steamer boat launch and nearby Clark's Grove, where clambakes and dances were held, were additional attractions for tourists. (Rose Fowler.)

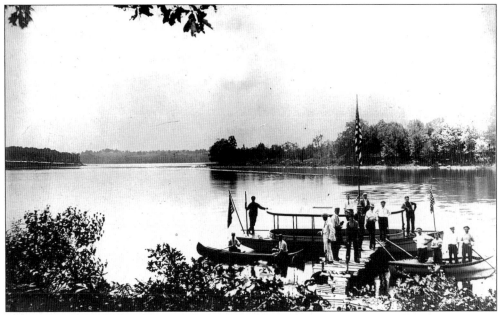

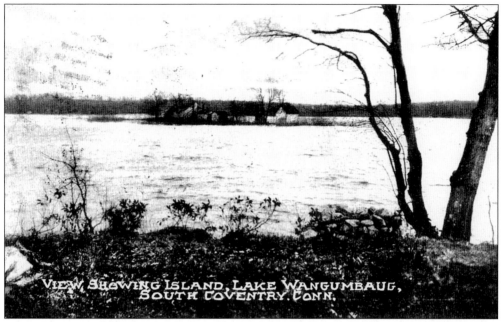

THE ISLAND, C. 1923. This view of the island was taken from the shore of the lake. On two occasions private homes were built on the island, and both times they burned down. Today, there is a small cabin at this location. (Patricia Pelkey.)

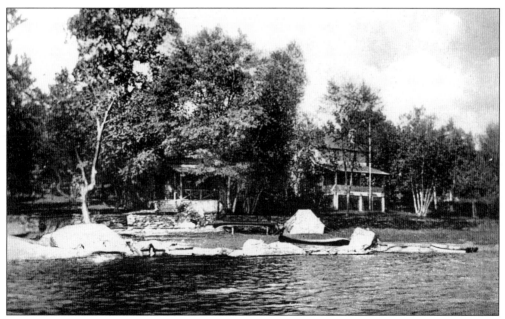

DAVIS ROCKS. These rocks are located off Standish Road near the property that was once part of the Ayer Farm. (David Mortlock.)

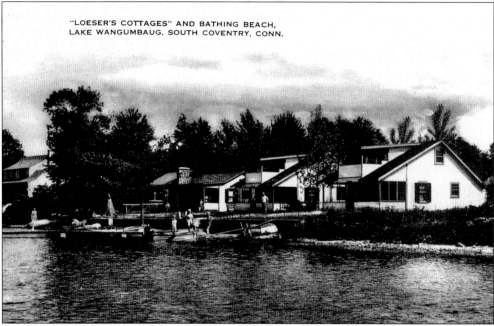

ACTOR'S COLONY. Retired vaudevillians Bill and Mabel Loeser discovered the quite beauty of the lake in the 1920s. They purchased land here and began selling lots and building rental cottages. Word was passed on to the show business community; gradually more performers from vaudeville, radio, and early television settled or vacationed here. This section of the lake became known as Actor's Colony. (Patricia Pelkey.)

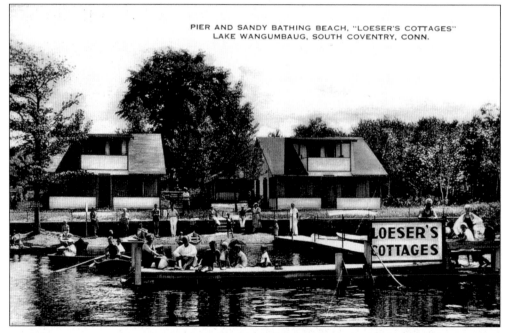

LOESER'S COTTAGES

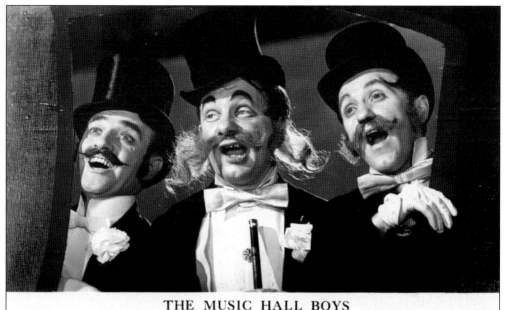

THE MUSIC HALL BOYS

F. KAMPLAIN. VAN KIRK. A. STIRLING.

VAUDEVILLIANS IN COVENTRY. Frank and Ann Kamplain were one of the show business couples who settled here. Frank Kamplain was a member of the vaudevillian singing and comedy act the Music Hall Boys. The group's presentation of "The Three Gay Blades" was described as an outstanding gay nineties act with excellently blended voices and a wonderful comedic flair. Once a year, beginning on August 25, 1933, the actors would stage a performance at the casino as a fund-raiser for their lake association. This section of the lake is now called Gerald Park. (Anne Kamplain, Patricia Pelkey.)

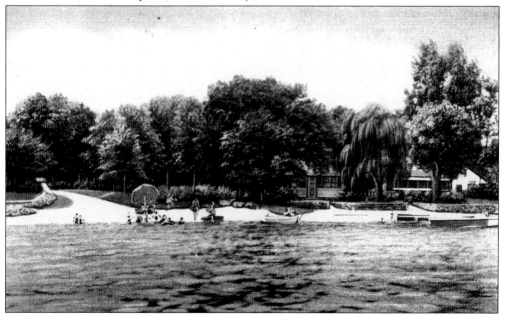

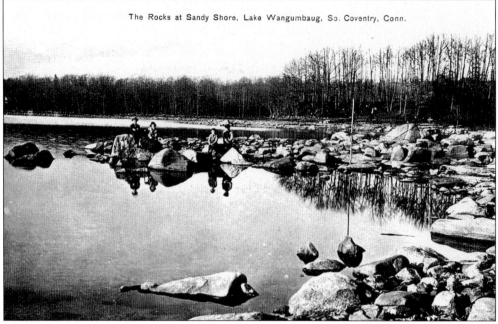

The Rocks at Sandy Shore, Lake Wangumbaug, So. Coventry, Conn.

SANDY SHORE. These individuals are taking time to relax on the rocks by Sandy Shore, now part of Patriots Park.(Rose Fowler.)

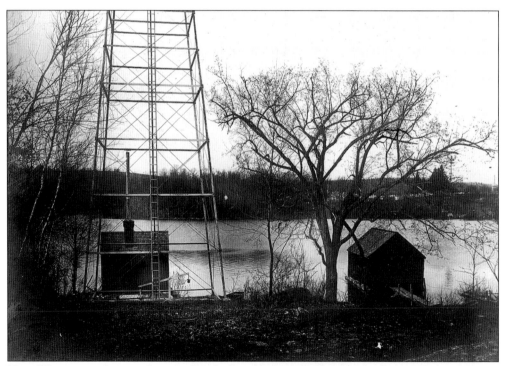

THE WINDMILL, SANDY SHORE. Frank Spaulding erected a windmill by Sandy Shore to provide water for his farm on High Street. The windmill was near the site of a cattle pond of earlier times, which was located closer to the road. (Coventry Historical Society.)

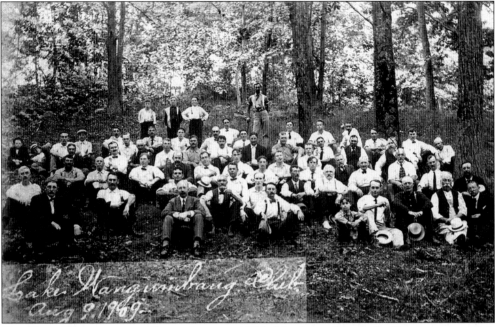

THE LAKE WAMGUMBAUG CLUB, AUGUST 1909. Members of the Lake Wamgumbaug Club gather by the lake. (Walter Jacobson.)

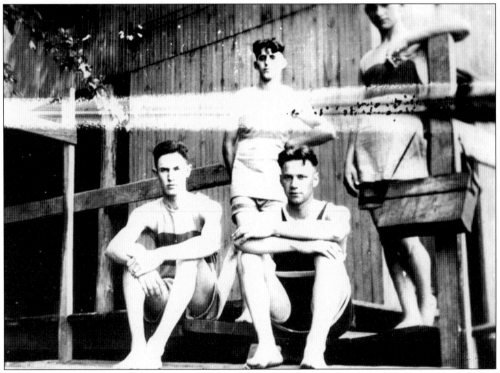

SWIMMERS AT LAKESIDE PARK, C. THE 1920S. Relaxing after a swim, from left to right, are the following local residents: (front row) Herman LeDoyt and Herman Meyer; (back row) Henry Kelly and Ralph Von Deck. (Coventry Historical Society.)

NATURE STUDY — NATHAN HALE CAMP. SOUTH COVENTRY. CONN.

THE SALVATION ARMY CAMP, C. 1929 TO THE 1980S. Camp Nathan Hale was a summer camp located at Sandy Shores. It consisted of 10 or more c. 1935 buildings, including a large dining hall. The property, situated on one of the most beautiful spots on the lake, was purchased by the town during the 1980s. It is now Patriots Park. (Patricia Pelkey, François J. Gamache.)

FUN ON THE MERRY-GO-ROUND. NATHAN HALE CAMP.
SOUTH COVENTRY. CONNECTICUT

Five

ALL AROUND TOWN

THE BARBER FARM. The Barber Farm, on Cooper Lane, depicts the essence of Coventry life in the early 1900s—a time of farmers, barns, horse-drawn carriages, and stone walls. (Arnold Carlson.)

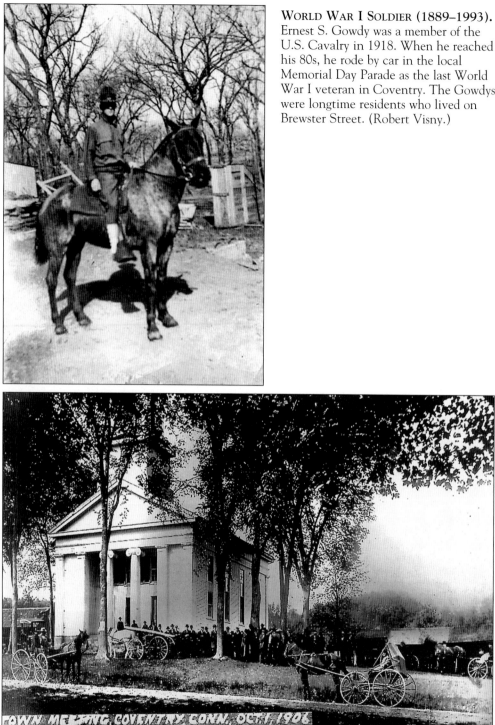

WORLD WAR I SOLDIER (1889–1993). Ernest S. Gowdy was a member of the U.S. Cavalry in 1918. When he reached his 80s, he rode by car in the local Memorial Day Parade as the last World War I veteran in Coventry. The Gowdys were longtime residents who lived on Brewster Street. (Robert Visny.)

TOWN MEETING, OCTOBER 1, 1906. Men meet at the Second Congregational Church to decide town issues. This annual meeting was held before the time when women had the right to vote. (Rose Fowler.)

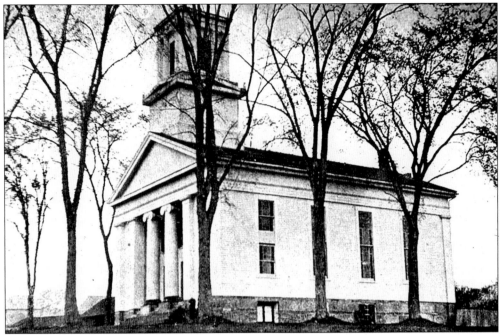

THE SECOND CONGREGATIONAL CHURCH. In 1740, the residents of the north section of Coventry petitioned the Connecticut State Assembly to be separated from the First Parish. The Second Congregational Church was organized on October 8, 1745, because of the inconvenience of going so far to worship, especially in bad weather. It took five years to build a church. The Reverend Nathan Strong was called as the first pastor; he stayed 50 years. He married Esther Meacham, daughter of the pastor of the First Congregational Church. In 1792, a second meetinghouse was built. Carriage sheds were located out back, and each bay was owned by a family. The present church was built in 1847 at a cost of $3,700. (The 1905 Church Manual.)

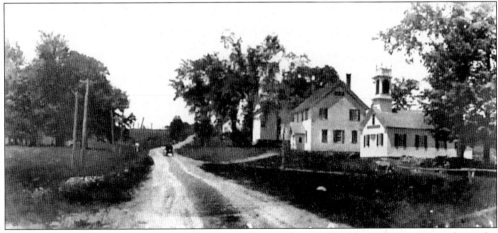

THE SECOND CONGREGATIONAL CHURCH, CHAPEL, AND GRANGE HALL. Located on the Boston Turnpike, this is the church building as it appeared after 1847. The chapel hall was constructed in 1889 to be used for social activities and Sunday school. The academy building was constructed in 1834; it served as a chapel and a select school until 1889, when it was sold to the Grange. (Walter Plowman.)

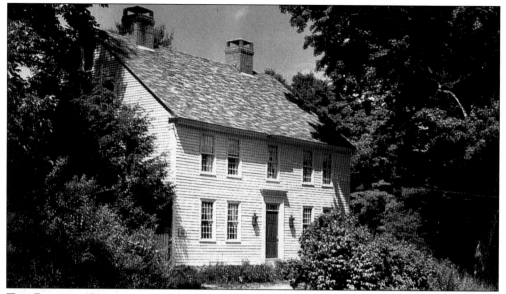

THE POMEROY TAVERN AND STAGE HOUSE, 1801–1804. This tavern and stage house was built by Eleazer Pomeroy to accommodate stagecoach travel on the new Boston Turnpike, which opened through Coventry in 1804. The building served as a post office from 1892 to 1905. (*Colonial Homes Magazine*, February 1991.)

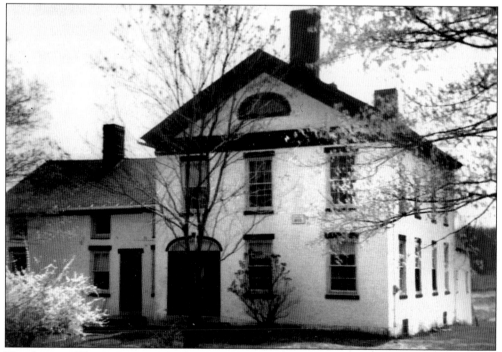

THE LOOMIS HOUSE, 1832. This home was built by Eleazer Pomeroy, owner of the Pomeroy Stage House, to be used as his residence. During the 20th century, the property was bequeathed to June Loomis by her sister Martha Pierce. A dedicated humanitarian, Loomis upon her death donated the property to the town through the Porter Library. The Booth and Dimock Memorial Library has been the beneficiary of the property's return to private ownership. (Ethel Harris.)

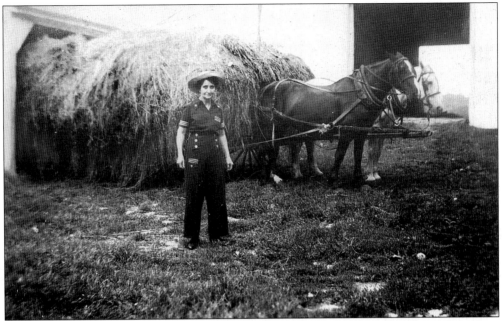

THE STORRS FARM. Mary Chase Storrs is pictured in 1943 with horses Mandy and Jack. Born in 1891, she worked on the family farm, at the corner of Route 44 and Grant Hill Road, all her life. The wife of Gilbert Storrs, she recounted life as it was in the early 1900s at the age of 83. (Robert Visny.)

VINTON'S GARAGE AND STORE, 1938. Arthur and Zoetje Vinton operated this store on Route 31 for more than 50 years. It all began with square dancing events on the second floor of the big barn, where refreshments and cigarettes were sold to the dancing crowd. Both husband and wife were very involved in the town, holding both local and state political offices, serving as 4H leaders, and volunteering for the North Coventry Fire Department. Arthur Vinton died on June 10, 1974. (Joy Kelleher.)

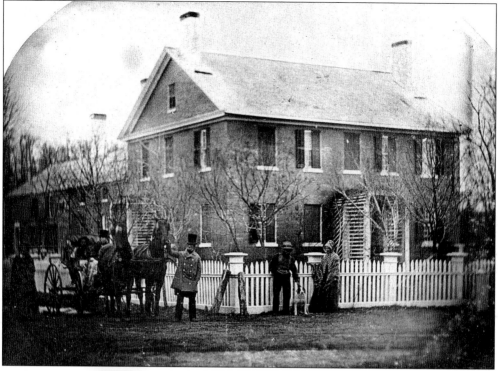

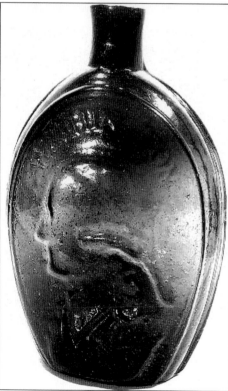

THE COVENTRY GLASS FACTORY. Located on the corner of Route 44 and North River Road, the glass factory was established in 1813. The company made pocket and snuff bottles, ink wells, medicine containers, highly valued whiskey flasks depicting railroad scenes, and busts of George Washington, Andrew Jackson, and Lafayette. Pictured to the left is a pint Washington and Jackson flask of deep olive-amber color, with a pontil scar, glass bubbles, swirl lines, and a sheared and fire-polished mouth. Production ended *c.* 1850. The site is now the Connecticut Museum of Glass. (Arnold Carlson.)

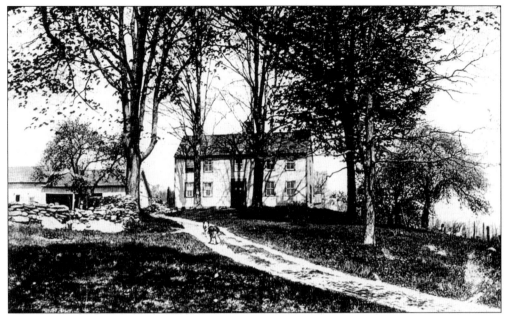

THE OLD CLARK PLACE, C. 1757. Located across from what is now Lisicke Beach, this two-story, center-chimney Colonial was in the Clark family for 150 years. Tourists were treated to boat rentals, beach outings, cabins, and camp sites, as the family transitioned from farming to catering to the tourist trade. (Rose Fowler.)

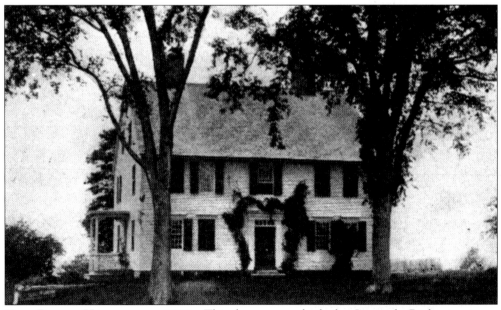

THE RIPLEY HOMESTEAD, 1792. This house was built by Jeremiah Ripley, assistant commissary for the state during the Revolutionary War. Ripley had a very successful store at this site. Across Ripley Hill Road is where the 116 Coventry men assembled to march off to Concord and the Battle of Bunker Hill. A stone monument now marks this site. (*Official Program, 1912 Celebration.*)

COOPER LANE AND ROOT ROAD. This view shows the dwellings of the Whites, Jacobsons, and Colmans. The original house, in the middle, dates from 1732. The large Colonial, on the left, dates from 1772. The farm, on the right, dates from 1832. Pictured at the left is Root Road, a steep dirt road leading to Route 31. (Walter Jacobson.)

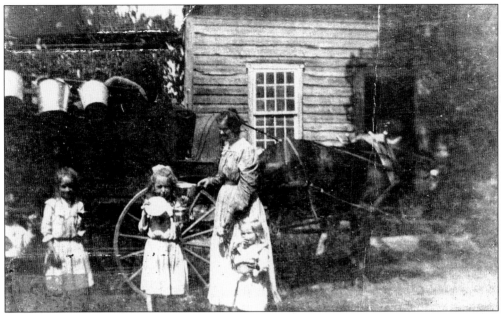

A Visit by the Tin Peddler. The Tin Peddler stops at the White-Jacobson Homestead, on the corner of Cooper Lane and Root Road. The peddler had a regular route of homes that he visited. Housewives would save anything to barter with, especially worn-out fabric such as woolens, cotton, and, the most valued, linen. The house in the background was built in 1732 by James White. When a large Colonial home was built in 1772, this smaller one became a cooper shop. (Walter Jacobson.)

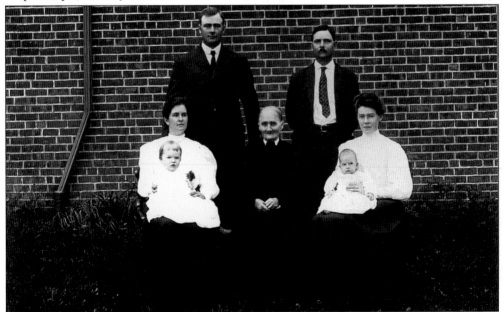

The Jacobson, White, and Bushnell Family, c. 1906. Pictured from left to right are the following: (seated) Mary White Jacobson holding baby Margaret Jacobson, Anna M. Johnson Jacobson, and Anna Jacobson Bushnell holding baby Forbes Bushnell Jr.; (standing) George Goodwin Jacobson I and Forbes Bushnell Sr. (Walter Jacobson.)

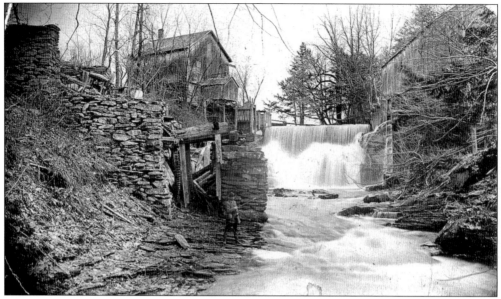

WRIGHTS MILL, C. 1727. Now Bynes Falls, the mill is located on South Street on the bank of the Skungamaug River by the "great falls." In 1726, Lazaros Manley entered into an agreement with the town to erect a sawmill "forthwith" and a gristmill as soon as 16 families were nearer to him than to any other mill place. A succession of owners followed until 1762, when the mill came into the possession of Elijah Wright Sr. The mill remained in the Wright family for several generations. It was later used for the production of cloth dressing. Pictured fishing in this late 1800s photograph is J. Patten Fitch. (Coventry Historical Society.)

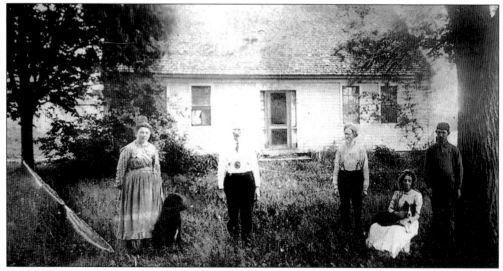

THE MILLERS' HOUSE, C. 1756. Located on South Street across from Wrights Mill, this home was built by John Fowler to accommodate the miller. Several generations of Wrights lived here, spanning almost 100 years. Pictured on June 6, 1904, are Marcus and Sarah Aspinwall, son, Ernest (to the right), and boarders, Mr. and Mrs. Fred Olds. Aspinwall, a farmer, carpenter, and wagon maker, wrote in his diary on a daily basis. His record of daily transactions offers insight into the necessities of farming, trading, and bartering in the early 1900s. (Donald and JoAnn Aitken.)

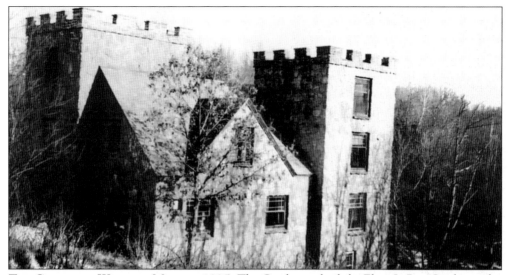

THE CASTLE AT WRIGHTS MILL, C. 1935. The Castle was built by Elam LeRoy Gardner, who dismantled his residence in Chester, Massachusetts, shipped it by flatbed railroad cars, and transformed it into a "Towering Medieval Fantasy." The process began in 1929. By 1938, Gardner was about half finished, according to the recollections of his grandson Stephen Birmingham, who published his story, "My Grandfather's Castle" in the *New Yorker*. An engineer by profession and a skilled carpenter, Gardner was a believer in deriving energy from waterpower rather than fossil fuel. He proceeded to build a higher dam, creating a higher waterfall and a new millpond to generate his own electric power. When his power station was completed, he hoped to sell electricity to the neighboring area. Although this plan was thwarted by the local utility company, the system functioned very well at the Castle for the remainder of his life (1945). His was the only home in Coventry to have electricity following the devastating hurricane of 1938. (Connecticut Historical Society.)

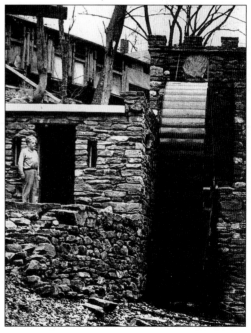

THE WATERWHEEL AT WRIGHTS MILL, C. 1940. Ralph McLeod, an electrical maintenance foreman, purchased the 45-acre property during the late 1940s. He decided to install a large overshot waterwheel, in addition to the turbine installed by the original owner, to drive a 30-kilowatt alternating current generator. Together, these devices provided him with more than enough power to meet his needs and freed him from dependence on the water level of the river. (Connecticut Historical Society.)

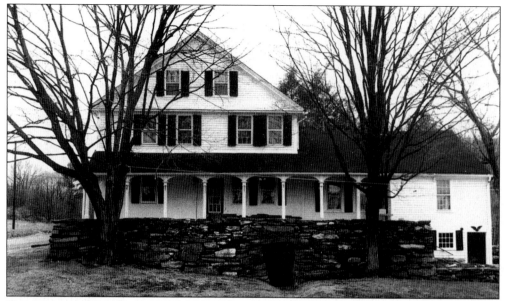

THE BRIGHAM TAVERN, C. 1725. The earlier portion of this structure, located at the corner of Route 44 and Brigham Tavern Road, dates from 1689. The building, which features a taproom and a ballroom on the second floor, served as a tavern for many years. George Washington stopped here on November 9, 1789, during his inaugural tour, noting in his diary "breakfasted at one Brigham's in Coventry." This home, which was also a stop on the Underground Railroad, is listed on the National Register of Historical Places. (Erik and Alysia Williams.)

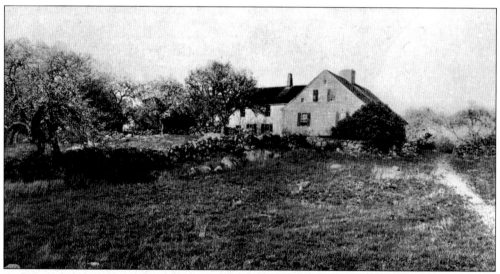

A HILLSIDE HOMESTEAD, COVENTRY. This photograph was taken by the Reverend Dr. Wallace Nutting, who was forced to leave the pulpit due to poor health at the age of 43. He began taking photographs during bicycle trips to the countryside. Although millions of copies of his photographs were sold, he did not consider himself to be an artist but rather "a clergyman with a love of the beautiful." The location of this homestead is unknown, but the photograph may have been taken during a recorded visit with his friend George Dudley Seymour at the Hale Mansion. (Judy Hynes.)

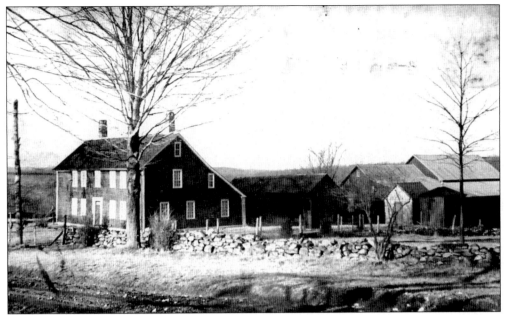

THE PORTER FARM. This historical structure is now the Strong-Porter House Museum, owned by the Coventry Historical Society since 1979. Located on South Street near the Hale Homestead, it has been described as one of the outstanding added lean-to salt-boxes in the state. The early half of the home was built *c.* 1733 by Aaron Strong, Nathan Hale's great uncle. The Porter family, who resided here for more than 150 years, built the western half and the lean-to kitchens *c.* 1770. Antiquarian George Dudley Seymour purchased the home in 1930 from the Porter heirs and renamed it the North Hampton House. (Connecticut Historical Society.)

THE COVENTRY DAY SCHOOL, C. THE LATE 1800s. This school was established in 1941 by Mr. and Mrs. Donald Churchill as a private coeducational elementary school. Located at the corner of Judd Road and South Street, the home was earlier called the Babcock House. (Arnold Carlson.)

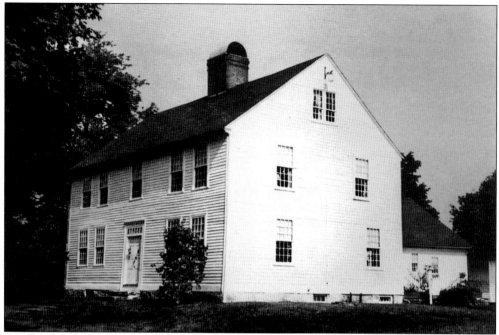

THE REVEREND DR. JOSEPH HUNTINGTON HOUSE, C. 1763. Called the Parsonage House, this was the home of Joseph Huntington, the noted scholar who graduated from Yale College, ministered to the First Church, and tutored Nathan Hale in preparation for his college years at Yale. (Rose Fowler.)

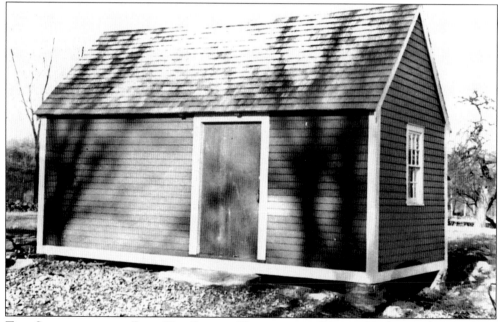

THE SCHOOL AT THE REV. DR. JOSEPH HUNTINGTON HOUSE. Nathan Hale may have attended school here in preparation for his entrance to Yale. This approximately nine-foot by eight-foot structure was being used as a storage shed when this photograph was taken in 1935. (Connecticut Historical Society.)

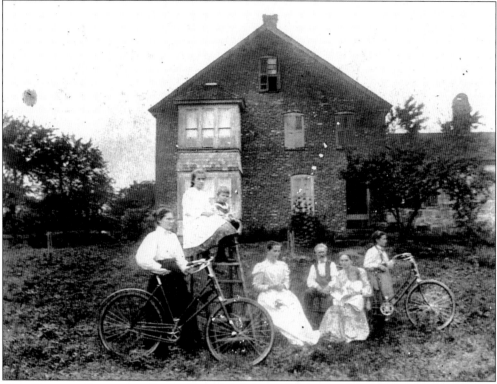

THE COLMAN-CRICKMORE FARM. Dorothy Colman Crickmore, born 1897, is in the arms of her mother, Julia W. Colman, at their home on High Street. This 250-acre farm included five apple orchards, chickens, and food crops. (Ethel Harris.)

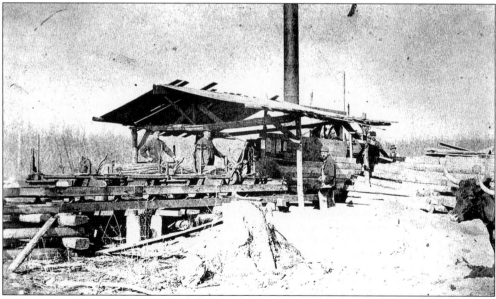

A PORTABLE SAWMILL, C. THE EARLY 1900S. This mill was located on High Street across from the large Crickmore Farm. It was owned by Marvin P. Colman, grandfather of Ethel Crickmore Harris. (Ethel Harris.)

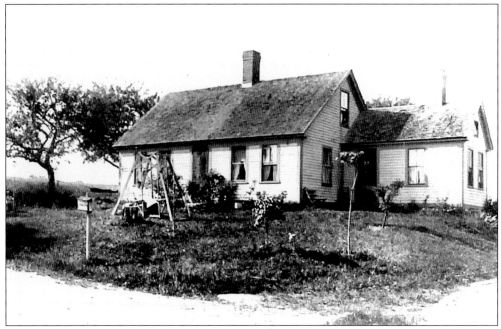

THE FRANZ HOME. Three generations of the Franz family have lived in this home, located on Flanders Road. The house is pictured in the early 1900s, when it was owned by Sarah E. Wolfe. (Walt Plowman.)

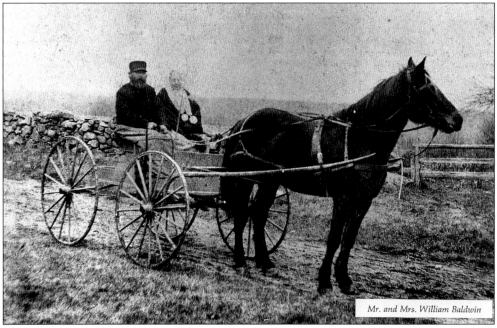

Mr. and Mrs. William Baldwin

MR. AND MRS. WILLIAM BALDWIN. The Baldwins lived at the corner of Route 44 and Trowbridge Road. Mrs. Baldwin's cookies were very popular with the schoolchildren, especially Byron Hall, as they walked to the Pond School on Route 31. John Hetzel told the story of her recipe for "Joe Froggers" in the 1976 Bicentennial Cookbook. (Coventry Historical Society.)

Six

EARLY SCHOOLS

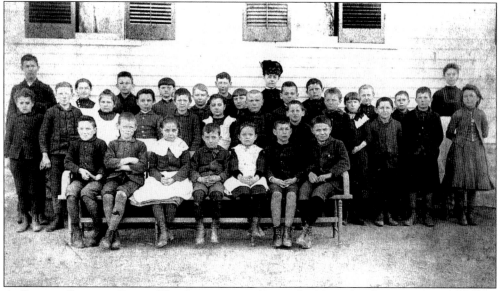

A CENTER SCHOOL CLASS. The first actions taken to build a schoolhouse were recorded in 1726 as a petition to the Connecticut General Assembly. In 1728, a school site was set within 20 feet of the meetinghouse, and the schoolmaster's salary was set at £11 for the winter quarter. It was not until 1911 that a request was made for a superintendent of schools. Class pictures were found of 9 of the 10 school districts. Shown here is a Center School class in March 1889. (Fred White.)

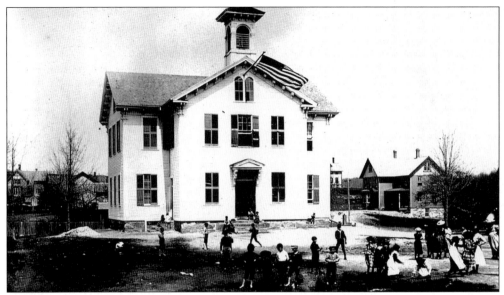

DISTRICT NO. 1, THE CENTER SCHOOL, C. THE LATE 1800S. This school, erected in 1873 at the corner of Main and School Streets, was the first two-story school in Coventry. There were four rooms, two on each floor, with two grades in each room: grades one through four downstairs and grades five through eight upstairs. The land and building cost $6,900; furnishings included "patent seats and desks and abundant blackboards" at a cost of $3,500. Destroyed by fire in 1963, the school was not rebuilt. (Rose Fowler.)

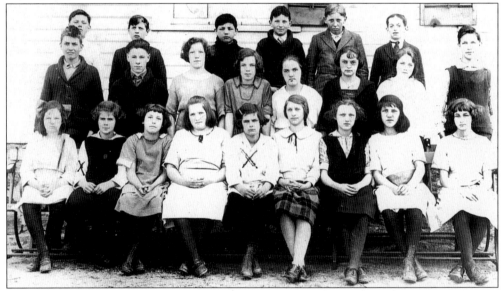

THE CENTER SCHOOL, MAY 1923. Shown are students in the seventh and eighth grades. From left to right are the following: (front row) Bernice Clark, Elizabeth White, Bertha Dainton, Bessie Thornton, Catherine White, Janet Kornorsky, Adelaide Stanley, Nellie Haddad, and Grace Von Deck; (middle row) Forbes Bushnell, Dennis Flaherty, Ella Carpenter, Irene Taylor, Pauline Pedro, Rose Heether, Alice Thornton, and Henry Moore; (back row) John Rister, Hyman Greenblat, Edwin Haddad, Raymond Boynton, Leslie Richardson, and Herbert Kelly. (Fred White.)

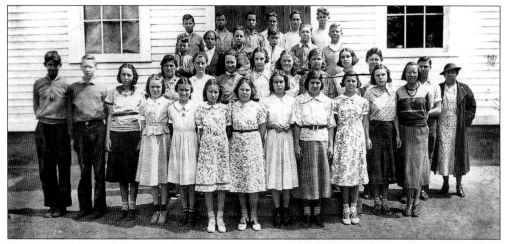

THE CENTER SCHOOL, 1937. Pupils of the Center School, from left to right, are as follows: (first row) unidentified, Walter Young, Anna Young, Margaret Champlin, Eleanor Graham, Eleanor Strede, Catherine Bour, Claire Porter, Rose Shirshac, Harriet Hoff, and Eunice Crickmore; (second row) unidentified, Faith Lee, Louise Chappell, Helen Flaherty, Theresa Kelly, Rose Eichner, Kathryn Grady, Fred Twerdy, Everett Colburn (principal and teacher), and Portia Fuller; (third row) John Cummisk, Ralph Kelly, Earl Clark, William Graham, Joseph Shirshac, and William Christensen; (fourth row) John Pedro, Herman LeDoyt, Edmond Postemski, Eward Hodis, unidentified, and Peter Hrenak. (Arnold Carlson.)

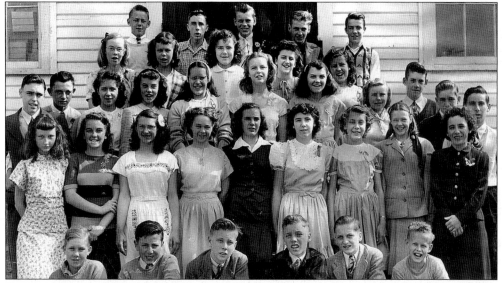

THE CENTER SCHOOL, GRADE EIGHT, JUNE 17, 1948. Graduates included Harold Hill, Bobby Upton, Richard Christensen, Walter Bassett, Donald Ellsworth, Richard Jackson, Lorraine Forbes, Agnes Porter, Edith Taylor, Edith Crickmore, Marilyn Loyzim, Dick Walsh, Tom Franz, Pauline Eichner, Elaine Johnson, Rita Diette, Leatrice Frankland, Shirley Smith, Winthrop Merriam Jr., Walter Green, Mary Kelly, Donna Green, Robert Brno, Bill Wiesner Jr., Georgianna Hill, Nancy Gates, Red Shippee, Lester Leighton, Alma Hill, Paul Ellison, Rodney Bloodgood, Nancy Granberg, Catherine Dorsey, Norman DeVeau, Frank Richardson, Ruth Sims, Joan MacDonald, Marie Maceyka, Walter Felsentreger, and Donald Green. Their teacher was Helen Bassett. (Walter Jacobson.)

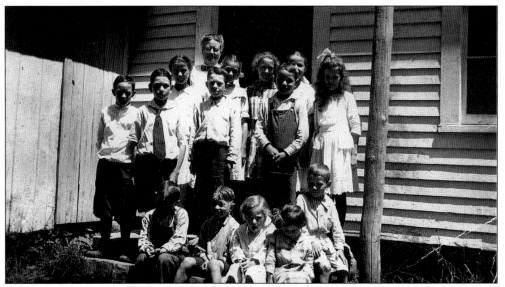

DISTRICT NO. 2, THE SOUTH STREET SCHOOL, JUNE 1919. The South Street School was located at the corner of South and Cross Streets. Among these students is Helen Dennick, the girl in the middle of the door. She will be the only one in eighth grade the next year and will attend the Center School, teacher Edna Newell wrote on the back of this postcard. (Rose Fowler.)

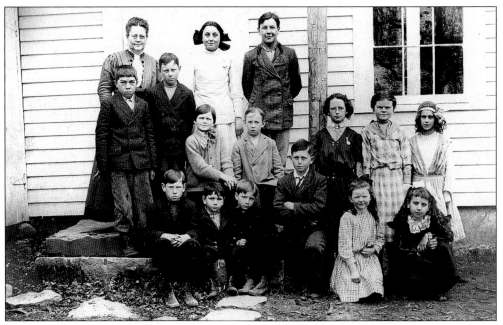

DISTRICT NO. 2, THE SOUTH STREET SCHOOL, C. 1912. Members of this class at the South Street School, from left to right, are as follows: (front row) Jack Oakley, Robert Von Deck, Ralph Von Deck, Robert Clock, Mildred Carpenter, and Ruth Wright; (middle row) Billy Phillip, Franklin Oakley, Howard Carpenter, Harry Small, Winifred Small, Viola Carpenter, and Eva Von Deck; (back row) teacher Edna Newell, Christine Phillips, and Clarence Bassett. (Coventry Historical Society.)

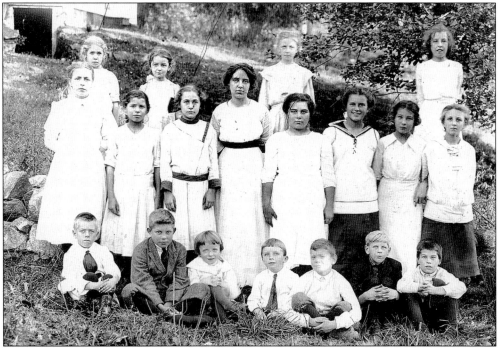

DISTRICT NO. 3, THE LOWER VILLAGE SCHOOL, MAIN STREET. Shown are students of the Lower Village School with their teacher *c.* 1913. From left to right in the upper photograph are the following: (front row) Fred Carrier, Bill Crookes, Bill O'Brien, Ray O'Brien, Arthur Nelson, Ted Beebe, and Leon Ohmen; (middle row) Dorothy Aborn, Helen Carrier, teacher Hannah Potter, Hulda Ohmen, Agnes Robinson, Annis Carrier, and Gertrude Noble; (back row) Florence Krombie, Ruth Noble, Vera Noble, and Mary Dainton. Those in the lower picture could not be identified. (Charles and Fran Funk.)

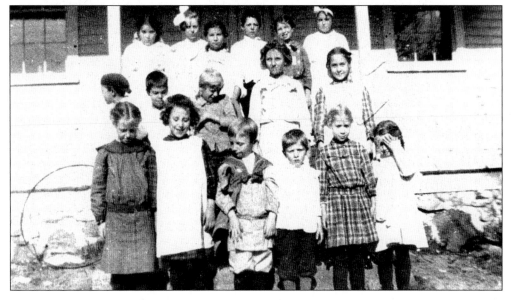

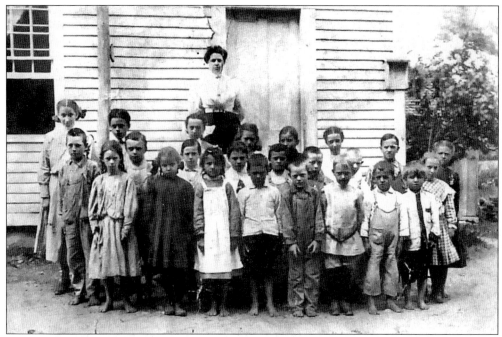

DISTRICT NO. 5, SOUTHEAST, THE FLANDERS SCHOOL, C. 1900 AND C. 1927. Pictured above are students with teacher Nellie Potter. The interior picture shows Health Club members at a weigh-in. From left to right are Charlotte Brainerd, Peter Twerdy, Margaret Clark, Joe Solenski, Annie Postemski, Ethel Crickmore, Charles Carpenter, and Verna Smith. (Walter Plowman and Coventry Historical Society.)

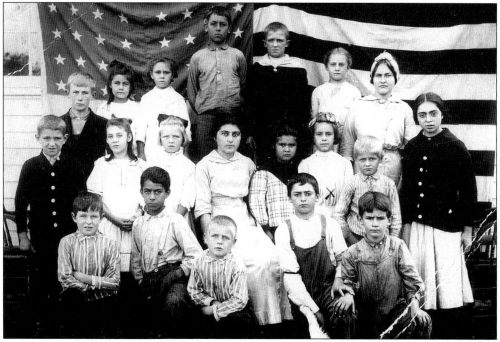

DISTRICT NO. 6, THE POND HILL SCHOOL, FLAG DAY 1910. Located at Route 31 and North River Road, this school housed grades one through eight. Lloyd Ayer has his hand on Franklin Orcutt's knee. Standing behind Orcutt, in a white dress, is Lillian Ayer. (William Ayer.)

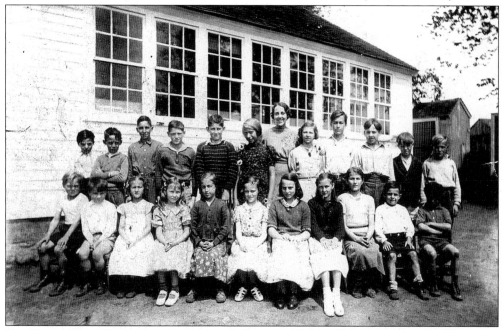

THE POND HILL SCHOOL, C. 1941. Jim Keller, second from left in front row, wrote to the Coventry Historical Society to donate this picture and memories of his school days. Among the students in this class are Alan Olsen, Mary Miller, Steve Youngerman, and Helen, Charlotte, Charles, and Ray Hicking. The teacher is Miss Taska. (Coventry Historical Society.)

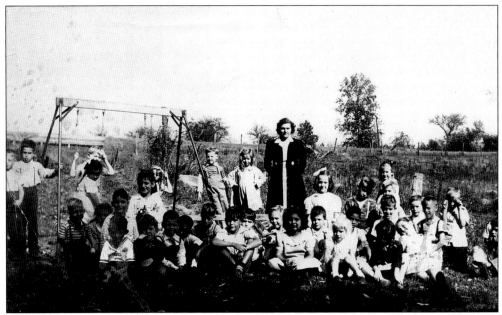

THE POND HILL SCHOOL, 1945. Pictured are grades one and two, with teacher Elizabeth Kubis. (William Ayer.)

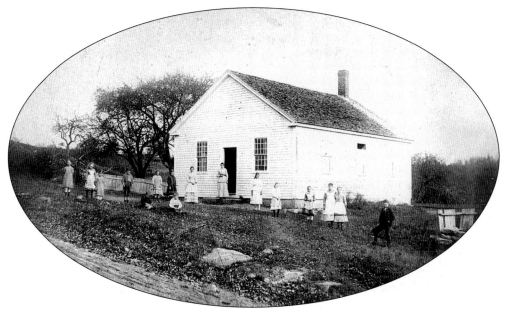

DISTRICT NO. 7, THE SILVER STREET SCHOOL, C. THE 1890S. This picture was found in the family papers of Roscoe P. Talbot of Andover. (Coventry Historical Society.)

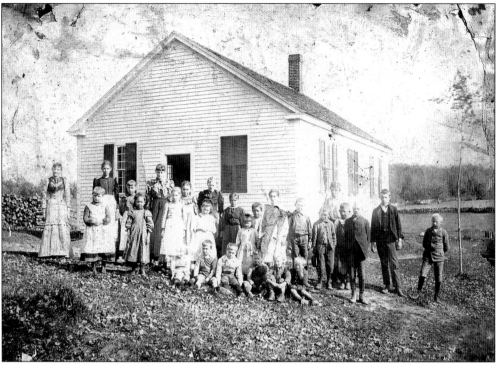

THE SILVER STREET SCHOOL, C. 1893. Pictured is the Silver Street School. (Coventry Historical Society.)

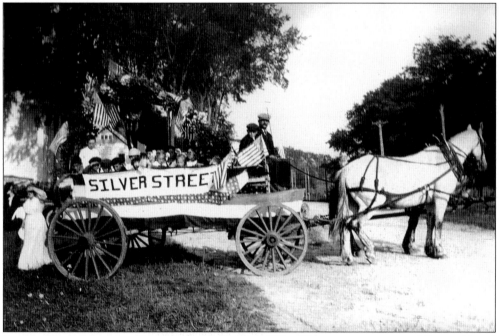

SILVER STREET SCHOOL FLOAT, C. THE EARLY 1900S. Shown are an unpaved Route 44 and the Silver Street School float entering the road by the Second Congregational Church lawn. (Judy Hill.)

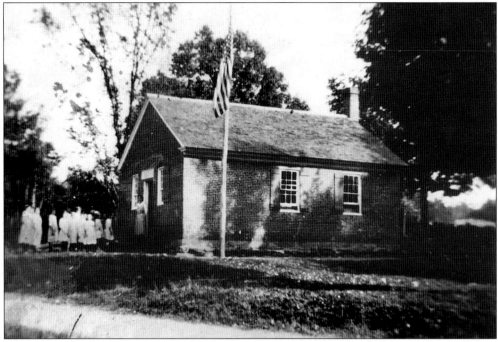

DISTRICT NO. 8, THE BRICK SCHOOL, 1823–1825. Situated at Merrow Road and Goose Lane, this building served as a one-room school until 1953. In 1967, it was given to the Coventry Historical Society by the town to be preserved. This was per the wishes of Mabel Walbridge Hall, a former teacher and student. She is pictured below with her sister—the two girls in white pinafores. (Coventry Historical Society.)

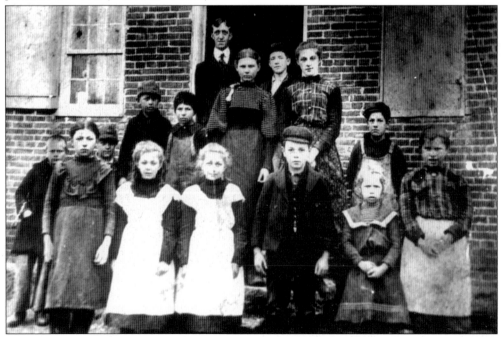

THE BRICK SCHOOL, 1941–1942. This picture was presented to each student at Christmas by teacher Evelyn Burdick. From left to right are the following: (front row) Walter Green, Diana Motycka, and John Eberle; (middle row) Donna Mae Green and Donald Green; (back row) David Motycka, Charles Eberle, and James Green. (Coventry Historical Society, Mrs. Joseph Motycka.)

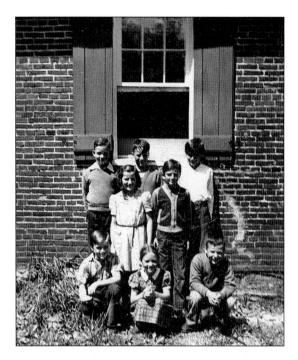

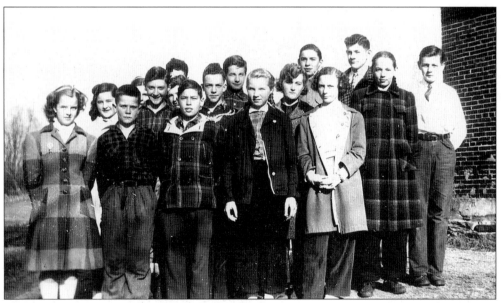

THE BRICK SCHOOL, 1945. This was the last eighth-grade class to graduate from this school. From left to right are the following: (front row) Virginia Battin, David Maceyka, Bobby Thorp, Joan Miller, Bernice Conkling, Gladyce Christensen, and Bobby Robertson; (middle row) Shirley Wright, Bobby Visny, Blanche Boynton, David Motycka, and Helen Hicking; (back row) Harriet Bowen, George Garbarini, Robert Meade, Robert Christensen, and Henry Reed. The teachers were Laura Edmondson and Eva Kingsbury. (Robert Visny.)

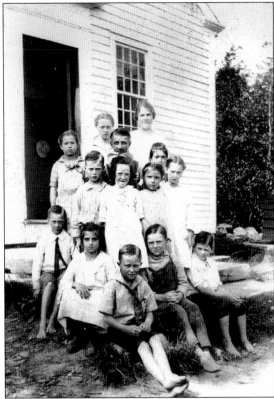

DISTRICT NO. 9, THE NORTH SCHOOL, C. THE 1920S. This school was located at the corner of North School and Dunn Roads. Pictured is teacher Marion Griswold Gowdy. Among the children is George Kingsbury, the first boy standing in the middle row. (Robert Visny.)

THE NORTH SCHOOL HEALTH CLUB, 1928. Shown are Health Club members and leader Esther Vinton. The club was organized in 1923 by Mabel Walbridge Hall to increase the weight of every club member. It was one of the first 4H clubs in Coventry. (Robert Visny.)

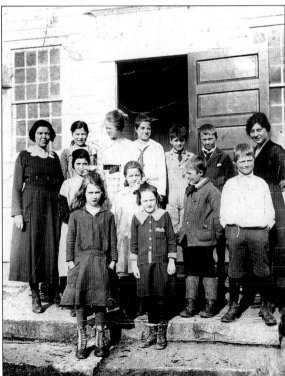

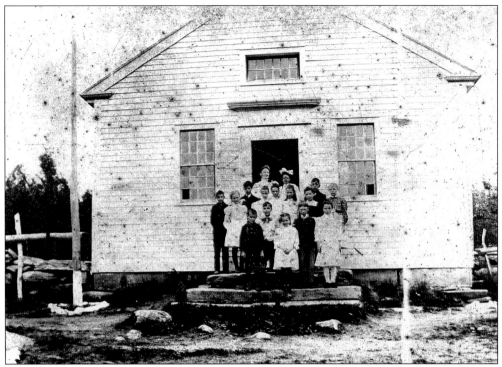

THE NORTH SCHOOL HEALTH CLUB, C. THE 1920S. Mrs. Christensen was the leader of this group. (Robert Visny.)

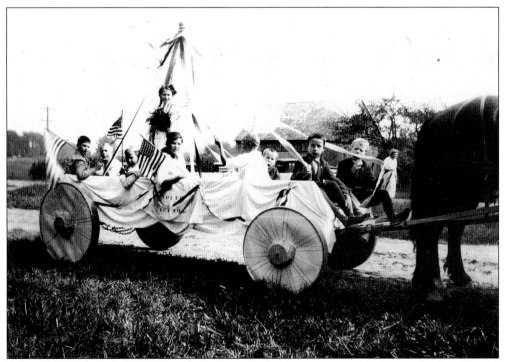

THE NORTH SCHOOL FLOAT, C. 1928. Shown is the float of the North School. (Robert Visny.)

DISTRICT NO. 10, THE RED SCHOOL, C. 1920. This school was located on Cedar Swamp Road. The painting was done from a photograph taken by Eunice Rose Wright. The school was burned by Coventry Fire Department *c.* 1955 (Coventry Historical Society, Shirley Wright Edmondson.)

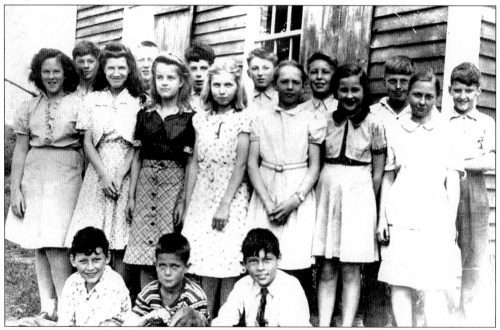

THE RED SCHOOL, 1943. From left to right are the following Red School students: (front row) Roger Sims, David Maceyka, and Robert Thorp; (middle row) Martha Cartwright, Blanche Boyton, Virginia Batten, Joan Miller, Gladys Christensen, Shirley Wright, and Bernice Conkling; (back row) Henry Reed, Robert Sturtevant, George Garbarini, Donald Heath, John Goldsneider, Robert Robertson, and Robert Visny. Their teacher was Mrs. Amprimo. (Robert Visny.)

Seven

ORGANIZATIONS AND EVENTS

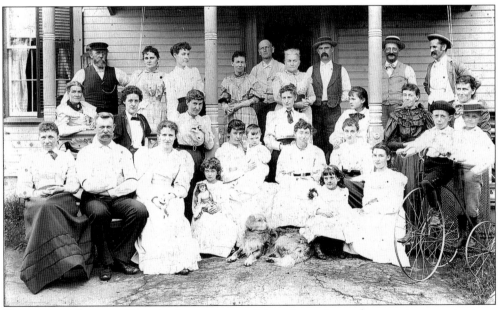

COMMUNITY CAUSES. Coventry has a great tradition of creating and supporting organizations, social events, and causes. This community spirit has given families and neighbors a way to be involved and a reason to look forward to annual events. Men, women, and children have come together for many good times. Pictured *c.* 1912 are members of the Crickmore, Colman, Tracy, Dean, Dunham, and Harmon families gathered in front of the building that is now the American Legion Hall, on Wall Street. Ethel Crickmore Harris is the young girl holding a doll in the front row on the left side. (Coventry Historical Society.)

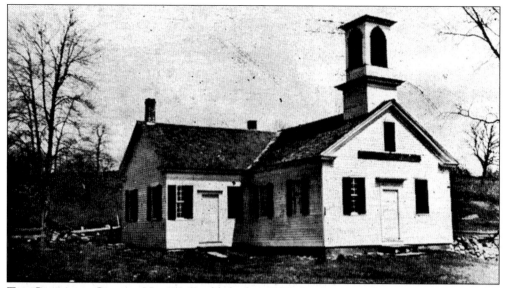

THE COVENTRY GRANGE NO. 75. Established in 1888, the Coventry Grange continues to this day. The building was purchased from the Second Society Church in 1889. The first meeting drew 24 members. The first master was Walter O. Haven. (Coventry Grange, Ethel Harris.)

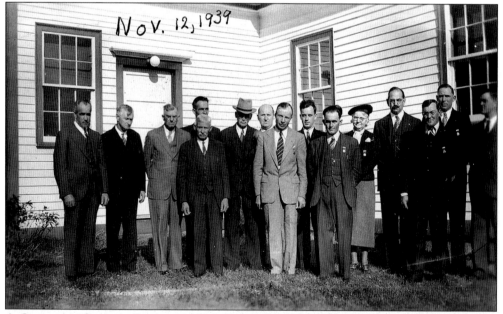

A COVENTRY GRANGE OFFICERS, 1939. Pictured on November 12, 1939, are officers of the Coventry Grange. From left to right are Byron Hall, John Kingsbury, Walter Haven, Arthur Reed, Raymond Johnson, Burton Pomroy, Lewis Highter, Fred Miller, Thomas McKinney, Frank Orcutt, Edith Haven, Arthur Vinton, Otis Hill, Charles Christensen, and Lester Hill. (Coventry Grange, Ethel Harris.)

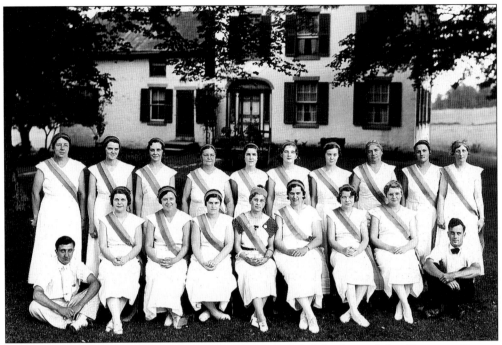

The Coventry Grange Ladies Drill Team, 1935. Members of the Coventry Grange Ladies Drill Team performed at Grange halls throughout the area. On the lawn of the *c.* 1834 Loomis House, from left to right, are the following: (front row) Raymond Storrs, Sylvia McKinney, Ruth Vinton, Rosa Johnson, Iva Standish, Camilla Highter, Ms. Reinhold, Ida Orcutt, and Thomas McKinney; (back row) Grace Reed (daughter), Marion Hill, Gertrude Anderson, Emma Hill, Dorothy White, June Loomis, Grace Reed (mother), Florence Crombie, Ms. Liebman, and Ruth Loomis. (Coventry Grange, Ethel Harris.)

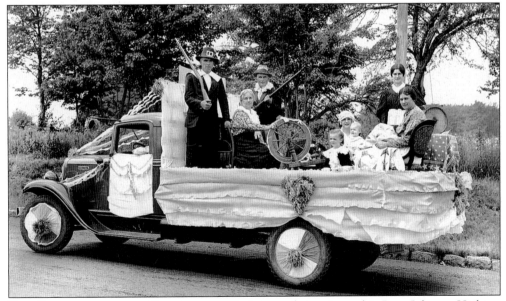

The Coventry Grange Float, c. 1935. Among those pictured is Rosa Johnson Highter, standing in the rear on the right. (Coventry Grange, Ethel Harris.)

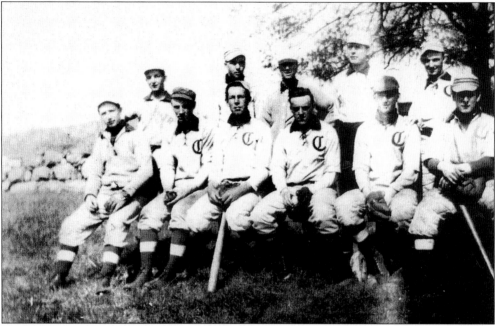

THE COVENTRY BASEBALL TEAM, 1908–1912. Postmaster Marvin Clark was the team organizer. The team is believed to have played at Wilson Field, behind the present library. (William Ayer.)

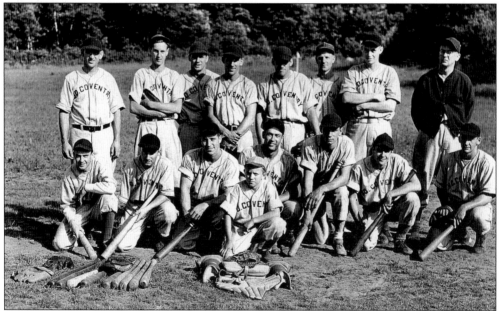

THE COVENTRY MEN'S BASEBALL TEAM, 1948. Taking part in the inter-Coventry game for the 150th anniversary of the town of Andover, from left to right, are the following: (front row) Casey Jones, bat boy; (middle row) Harman Cochran, Lou Haddad, Leo Morris, George Hinkle, Jake LeDoyt, Fred Rose, and Charlie Hawkins; (back row) Walter Thorp, Joe Sumara, Bud Gagnon, Johnny Leigher, Don "Gabby" Geer, Buster Beaumant, John Flint, and Lefty Woodworth. (William Ayer.)

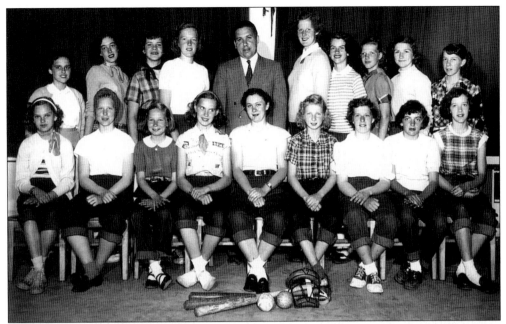

THE GIRLS' SOFTBALL TEAM, 1950. The coach of the girls' softball team at George H. Robertson School was William McArthur. The players included Lois Sawyer, Ruby Vance, Doris West, Lynn Cassidy, Barbara Barno, Lois Lyman, Elsie Anderson, Nancy Charland, Dolores Giglio, Gail Rychling, Jean Elsemore, Alice Crickmore, Lillian Luthi, Joan Koehler, Joan Ayer Lewis, Pat Jorgenson, Dorothy Ward, and Beverly DeCarli. (William Ayer.)

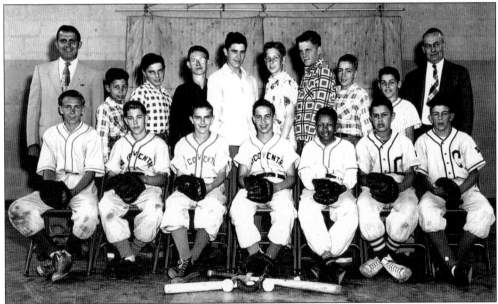

THE BOYS' BASEBALL TEAM, 1952–1953. Pictured is the George H. Robertson School's first organized team with uniforms. Players include Ronald Littell, Barry Pender, Lyman Albro, Phil Duell, David Mclaughlin, Steve Zaches, Alan Hernberg, Ed Corneilson, Robert Liebman, Bill Ayer, Raoul Diette, Joe Suggs, and Pete DeCarli. The coach was Frank Perrotti, and the school principal was Mr. Fisher. (William Ayer.)

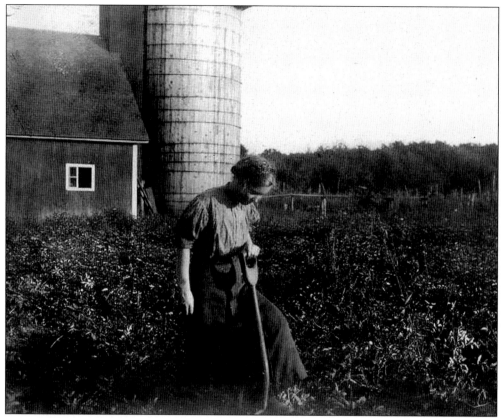

THE 4H POTATO CLUB, 1915. Bertha Green raised 400 bushels of potatoes per acre. This feat made headlines in the *Waterbury Herald*. (Robert Visny.)

THE 4H CANNING CLUB, 1928. George Kingsbury and Arnold McKinney demonstrated canning at Hartford 4H as county champions. The 4H Canning Club was founded in 1926 by Laura Kingsbury and Zoetje Vinton. In 1929, the club canned more than 1,000 jars of vegetables, fruits, jams, and jellies. (Robert Visny.)

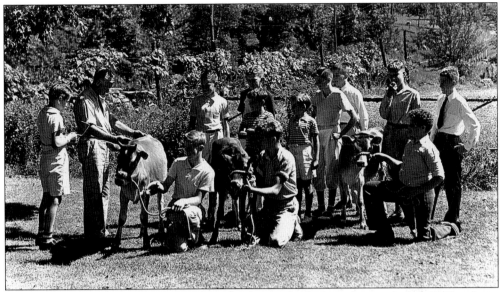

THE 4H CALF CLUB, 1937. With John Kingsbury as leader, members include Jack Kingsbury, Donald Gowdy, Chris Glenney, and Hubert Edmondson. (Robert Visny.)

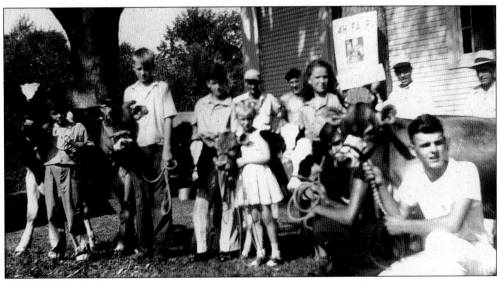

THE 4H COVENTRY TOWN FAIR, 1944. This fair was sponsored by the 4H Town Committee. The fairs continued for years because of the many 4H clubs, members, and the adult volunteer leaders who followed the tradition to "Make the Best Better." (Robert Visny.)

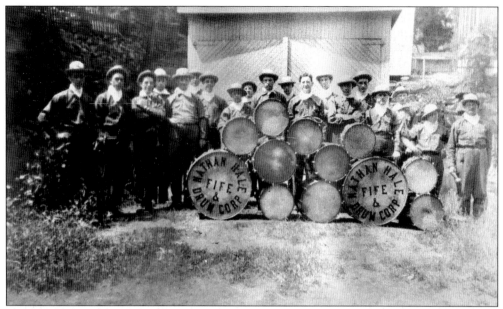

THE NATHAN HALE FIFE & DRUM CORPS. Organized in the early 1900s, the corps marched in many parades and participated in special events. Officers in 1914 were Joseph Clark (president), John Wadsworth (vice president), Joseph O'Brien (chairman), William Small (major), and Henry Frink (secretary and treasurer). Members are pictured above *c.* 1910 and below *c.* 1919. (Arnold Carlson.)

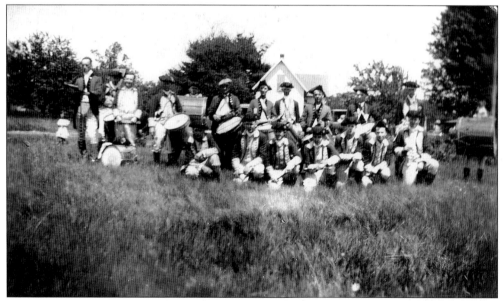

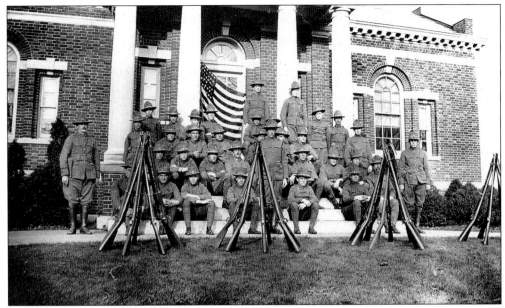

THE COVENTRY HOME GUARD. The Coventry Home Guard was organized on March 9, 1917, by a bill passed in the Connecticut General Assembly as the Nathan Hale Company of the Connecticut State Guard. The declaration of war made necessary a new constabulary force in each town to protect the people. Dr. William L. Higgins was appointed recruiting officer. A total of 75 men from South Coventry enlisted, with 18 men over 60 years of age placed on the Coventry Reserve Corps. The Coventry Home Guard was mustered out on January 17, 1919. (Arnold Carlson, Booth and Dimock Memorial Library.)

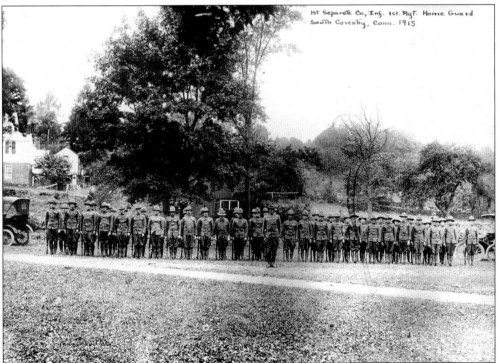

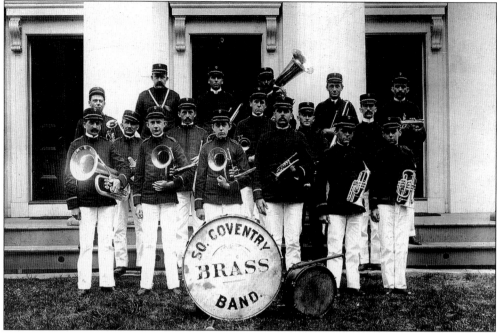

The South Coventry Brass Band, 1923. Members of the band assemble in front of First Congregational Church. Included are John Potter, Joseph Pippin, Ed Stanley, and DeWilt Kingsbury. (Arnold Carlson.)

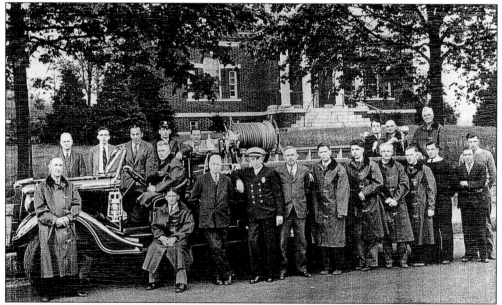

Coventry's First Fire Truck, 1936. Shown with Coventry's first fire truck, from left to right, are the following: (front row) William Loeser, Marcus Kelley, Louis Kingsbury, Chief Arthur Woodworth, Eugene Latimer, Delmar Potter, unidentified, Frank Boynton, Fred Wellworth, Edward Haddad, Floyd Wiley, and Harold Wolfe; (back row) Louis Phillips, Lawrence Latimer, George Hinkle, Raymond Boynton, unidentified, Oliver Frederickson, George Cour, and G. Burton Carpenter. The driver is Henry Frink. (William Ayer.)

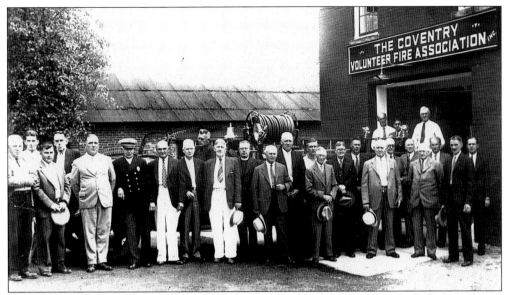

THE COVENTRY VOLUNTEER FIRE ASSOCIATION, 1936. Pictured with the fire truck in front of the firehouse, from left to right, are Floyd Standish, Raymond Boynton, Henry Reed, Thomas Flaherty, Lovis Grezel, Chief Arthur Woodworth, George Cour, Louis Phillips, Henry Frink, George H. Robertson, Rev. Father Kelley, Edward LeDoyt, George G. Jacobson, Frank Suffish, Perkins Lathrop, E.J. Beams, Delmar Potter, Herman Meyer Sr., Albert Harmon, Ed Stanley, Louis Kingsbury, Nathan Jacobson, Charles Schroeda, and J.L. Schweyer. Standing at the rear of the truck are Harold Griffith, Marcus Kelley, and G. Burton Carpenter. (Frank Kristoff.)

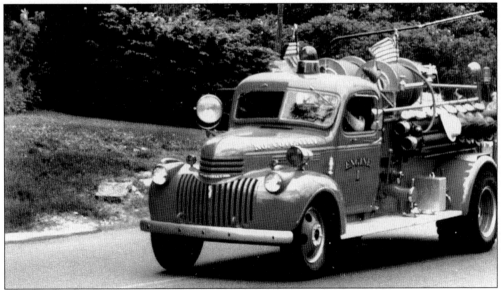

THE NORTH COVENTRY VOLUNTEER FIRE DEPARTMENT. The North Coventry Volunteer Fire Department was established on November 15, 1947, with Arthur Vinton as chief. An army-surplus, 1942 Chevrolet fire truck was garaged at Vinton's Barn. The department fought its first fire at the home of Martin and Lena Visny, on Route 31. The Vintons donated land across from their store for the new two-bay fire station, which was built in 1950. (Robert Visny.)

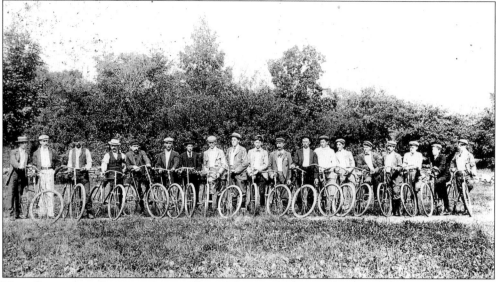

THE COVENTRY BICYCLE CLUB. This club was organized by Charles Coombs and John Champlin in the early 1900s. (Arnold Carlson.)

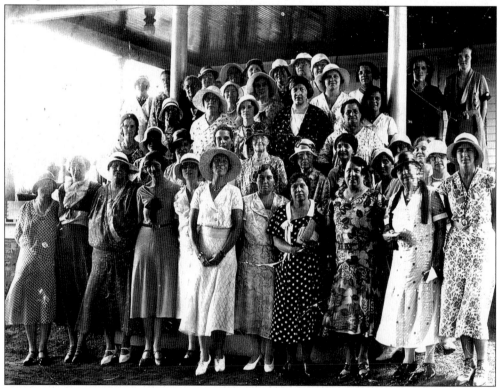

THE LEAGUE OF WOMEN VOTERS, C. THE 1930S. Shown are members of the newly elected executive committee of the League of Women Voters. From left to right in the front row are Mrs. G.H. Robertson, Margaret Jacobson, Mrs. J. LeRoy Schweyer, Mrs. J.D. Malcolm, Mrs. T.W. Graham, Gladys Orcutt, Mrs. Homer E. Wood, Mrs. H.C. Newcomb, Mrs. T. Clyde Overholt, Helen W. Sykes, and Grace Anderson. (Arnold Carlson.)

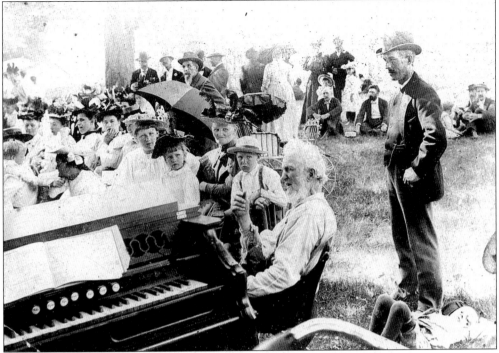

A Celebration on Memorial Green, 1912. The 200th birthday of Coventry was a time for many events and celebrations. Outdoor events held on the town green included music, food, and entertainment. These pictures depict that happy time. (Coventry Historical Society, Crickmore Collection.)

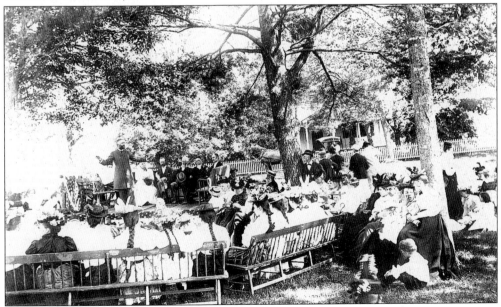

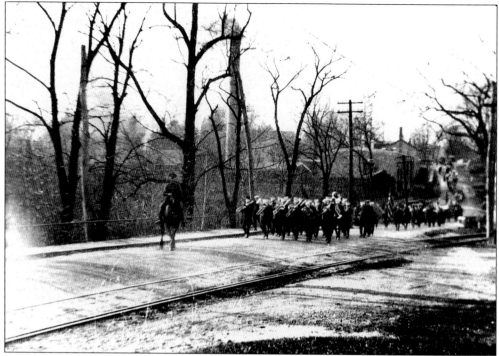

A PARADE ON MAIN STREET, NOVEMBER 11, 1923. This parade was held to remember the men who fought in World War I for our freedom. It included marching bands, horses, cars, and many residents who all paraded south down Main Street. (Coventry Historical Society.)

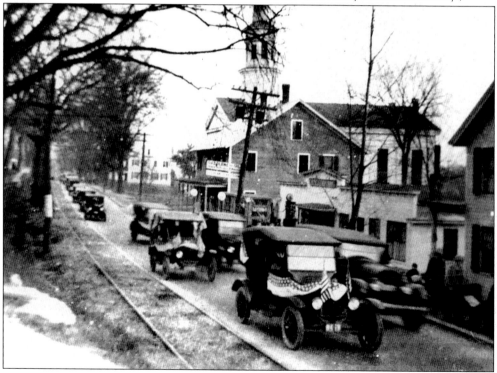

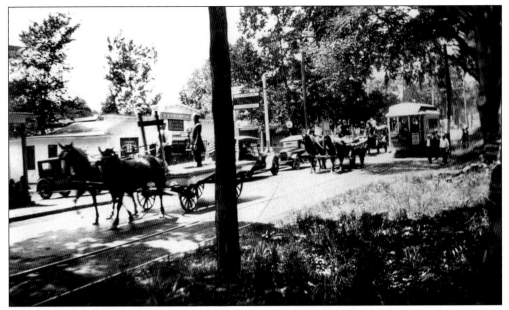

THE FOURTH OF JULY PARADE, 1926. This was a grand event celebrating the country's freedom. Floats, cars, horses, trolley cars, marching bands, and flags filled Main Street as the parade traveled south past Champlin's store. (Robert and Lois Frankland.)

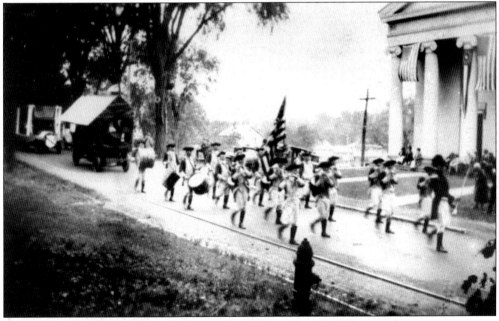

A PARADE TO HONOR NATHAN HALE, SEPTEMBER 22, 1926. The parade to commemorate the death of Nathan Hale passes the First Congregational Church. The float is a replica of a schoolhouse in which Nathan Hale taught. Alfred Crickmore is ringing the school bell, and the Nathan Hale Fife & Drum Corps is marching. (Arnold Carlson.)

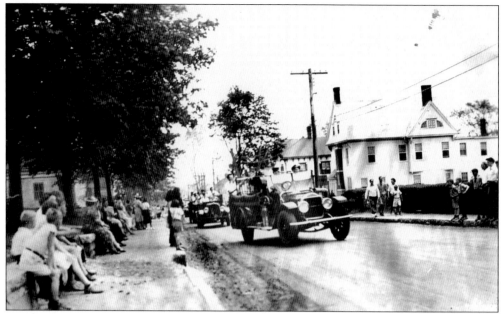

A PARADE WITH FIRE TRUCKS, C. THE 1940S. Parade watchers sit on the stone wall in front of the Booth and Dimock Memorial Library, as this parade proceeds up Main Street, Mason Street, Wall Street, and Monument Hill Road to the Nathan Hale Monument at Nathan Hale Cemetery. (Robert and Lois Frankland.)

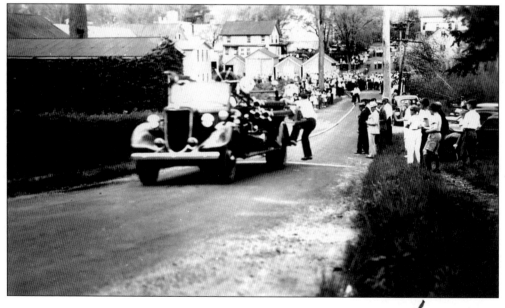